W9-DDN-030

ZKM | Center for Art and Media

Karlsruhe

ZKM | Center for Art and Media Karlsruhe

Prestel
Munich · New York

© Prestel-Verlag, Munich · New York, 1997
and
ZKM | Zentrum für Kunst und Medientechnologie Karlsruhe

Original German text compiled by Sibylle Peine, edited by Katharina Wurm
English text translated and edited by Elizabeth Clegg

Texts written by:
Annika Blunck
Ursula Frohne
Johannes Goebel
Ludger Hünnekens
Heinrich Klotz
Sibylle Peine
Rebecca Picht
Hans-Peter Schwarz
Oliver Seifert
Jeffrey Shaw
Birgit Stöckmann
Frauke Syamken

Photographs:
Evi Künstle: pp. 8/9, 13
ONUK: pp. 12, 15, 86/87
See also p. 119

© illustrated works on p. 119
© of floor plans on front inside cover: Holger Jost

Illustration on front cover: Factory building with the 'blue cube'
Illustration on back cover: Lynn Hershman, *Room of One's Own*, 1992/93, ZKM,
Media Museum

pp. 6/7: Lightwell
pp. 16/17: Frank den Oudsten, *Floating Identities*,
 Media Museum (cf. p. 22)
pp. 52/53: Lightwell with artworks from the Museum for Contemporary Art
pp. 86/87: Inside the Media Theater

Die Deutsche Bibliothek – CIP-Einheitsaufnahme

ZKM, Center for Art and Media Karlsruhe / [orig. German text comp. by Sibylle Peine,
ed. by Katharina Wurm. Engl. text transl. and ed. by Elizabeth Clegg. Texts written by:
Annika Blunck ...]. – Munich ; New York : Prestel, 1997
 (Prestel-museum guide)
 Dt. Ausg. u.d.T.: ZKM, Zentrum für Kunst und Medientechnologie Karlsruhe
 ISBN 3-7913-1883-7

Prestel-Verlag
Mandlstrasse 26, 80802 Munich
Tel.: + 49 89 38 17 090; Fax: + 49 89 38 17 09 35

Designed by Verlagsservice G. Pfeifer, Germering
Typeset by EDV-Fotosatz Huber, Germering
Printed and bound by Passavia Druckerei GmbH, Passau
Printed in Germany
ISBN 3-7913–1883–7

Contents

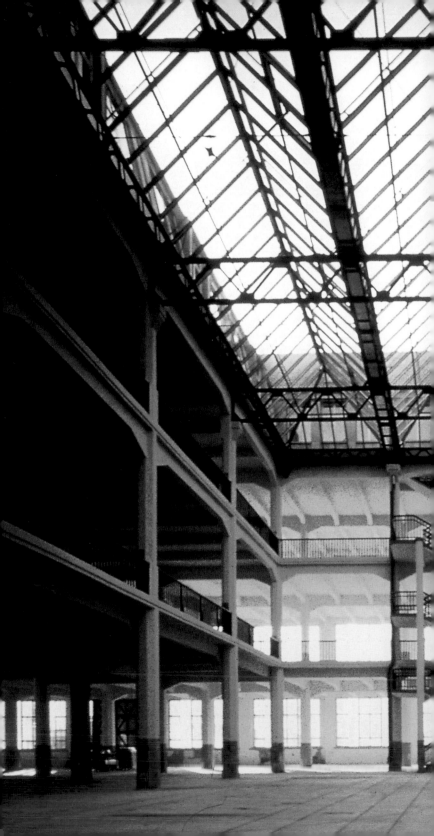

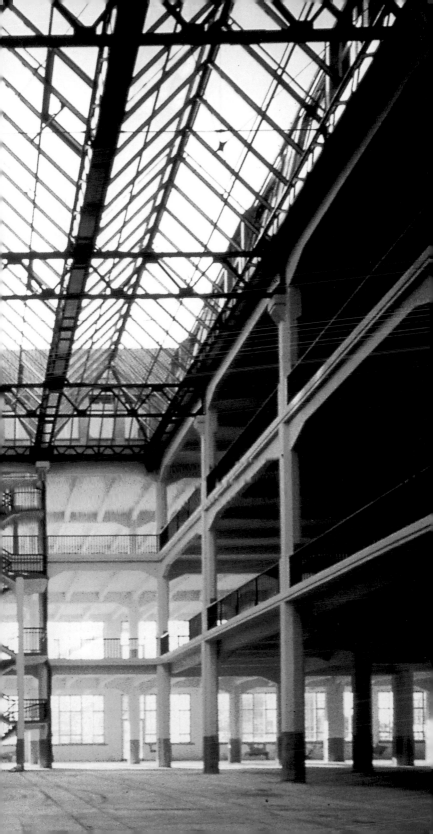

The Center for Art and Media: An Unprecedented Cultural Project

Origins

In retrospect it is astonishing that the Center for Art and Media did not remain merely a dream, an idea, a concept; and this is the more so when we bear in mind that it eventually came into being in an era of far-reaching political and social change. Although planned in a period of cultural upheaval, it was realized during the recession of the 1990s, when all cultural institutions were coming under scrutiny. Nonetheless, even in such a period, the Center received strong public support.

The idea of creating a Center for Art and Media originated in 1985. A working group and specialist committees were established, these bringing together local political figures with representatives of Karlsruhe University, the city's Academy of Fine Arts, its renowned Atomic Research Center and other important institutions. Their investigations and deliberations issued in the report 'Konzept '88'.

This recommended that the principal aim of a new Center for Art and Media in Karlsruhe ought to be to bridge the notable gap existing in Germany between art and the new media by committing itself to research and development in both spheres. Such an institution would explore the creative potential of the

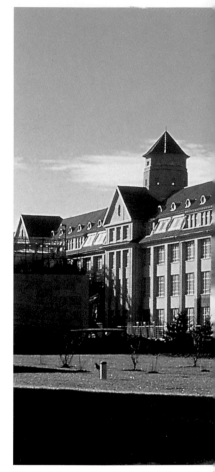

The East Façade of the Center for Art and Media

new technologies, assess their character and their impact on contemporaray art, and define their current and probable future influence on our lives. The Center was to have three departments devoted, respectively, to the 'Image', to 'Music' and to 'Media for the Public'. The 1988 scheme also embraced plans for several of the public spaces that are crucial components of the Center for Art and Media as we know it now – the Media Theater, the Media

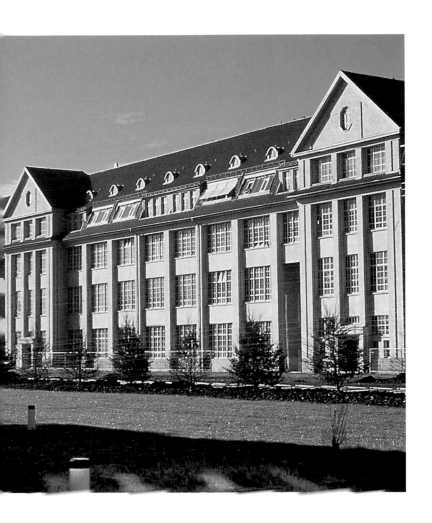

Museum, and the Media Library. Careful consideration was also given, at this stage, to the financial aspect of such an undertaking. The city of Karlsruhe recognized that the proposed new institution might be a very useful addition to the entire region because it would almost certainly attract further bodies committed to research and development, as also farsighted and innovative businesses. In particular, it understood that the Center would provide a crucial boost to urban re-planning in the southern part of the city beyond the main railway station, the proposed site for a new building to house it.

In May 1988 Karlsruhe City Council formally signalled that the project should go ahead, with a budget of DM 120 million. This decision, like earlier discussions of the plan, did arouse a certain amount of adverse criticism. Much of this was informed by a spirit of scepticism towards technology; and the fact

that the project was unprecedented was in itself an encouragement to this cautious or dismissive attitude. For those with other concerns, anxiety was provoked by awareness that the proposed Center would certainly mount a bold challenge to the conventional categorization of art.

It is easy to overlook the fact that, during this early phase of the project, entities and concepts that we now discuss almost every day, such as 'multi-media', 'the Internet', or 'virtual reality', were familiar only to specialists. This in itself reveals with what improbable speed the new media have evolved. This evolution in turn shows how far-sighted the decision taken in 1988 was. At that time, the public expenditure budget was not yet so strained, and the government of Baden-Württemberg, led by Lothar Späth, was still able to offer generous support for the arts.

In November 1988 the Baden-Württemberg authorities decided to establish the Center for Art and Media as a public foundation and to provide fifty per cent of its running costs. The remaining fifty per cent was to be provided by the city of Karlsruhe which would also cover the full cost of the planned new building. In 1989 the art and architectural historian Heinrich Klotz was appointed as Director of the new institution. Professor Klotz had recently been responsible for establishing the German Museum of Architecture in Frankfurt am Main, and had made a crucial contribution to the plans for that city's new riverside Museum Quarter. Klotz recognized that the planned Center for Art and Media offered the chance to create an institution for the media arts appropriate to the digital age, which would follow in the great tradition of the Bauhaus and the College of Design in Ulm. Plans for the workshops and studios, for the Institute for Visual Media and for the Institute for Music and Acoustics now took firmer shape. It was, moreover, decided that the Center should embrace a Museum for Contemporary Art. The year 1989 also saw the first Multimediale – a proposed biannual festival to be organized by the Center. In 1991 an Academy of Design was founded, in order to ensure the impact of the Center for Art and Media in the realm of art education. The first intake, of eighty students, entered the Academy in the summer semester of 1992. This was the first German institution to put particular emphasis on a training in the media arts, offering, for example, an MA course in media theory. The Academy, of which Heinrich Klotz was appointed the first Rector, is closely connected in every respect with the Center for Art and Media.

A New Building – From Koolhaas's Cube to the Architecture of Recycling

While the first, crucial steps towards establishing the Center had been

taken, the proposed institution still lacked the additional dimension of identity that it might hope to derive through occupying a distinctive building. Such an unusual and innovative undertaking demanded an architecture that was similarly innovative. A competition for a design for a new building was therefore announced; and in late October 1989 the proposal submitted by the leading Dutch architect Rem Koolhaas emerged as the winner. Enthusiasm for Koolhaas's design was unanimous; and many predicted that the design Koolhaas proposed – a glass cube, sixty metres in height and reminiscent in its form of a computer monitor – would become one of the most fascinating buildings of the late twentieth century. At the very least it was clear that the city of Karlsruhe would acquire a bold new architectural landmark. Soon, however, it became apparent that the cost of building Koolhaas's cube would far outrun the originally estimated sum of DM 120 million.

At this point an alternative solution emerged. In 1989 the city of Karlsruhe had acquired the huge, listed building in Lorenzstrasse, south-west of the centre. Initially constructed, and used, as a munitions factory, it was in serious need of renovation, and the city would in any event have had to bear the cost of that. As yet, however, no new purpose had been found for this enormous building, one of the largest monuments to the industrial age in Germany. When the probable cost of realizing the Koolhaas design became apparent, it was not long be-

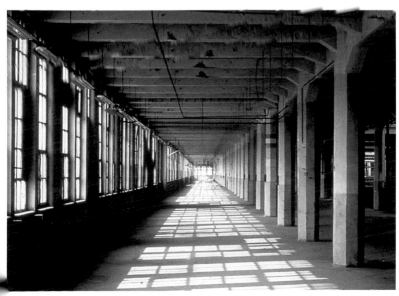

The former factory building before its conversion

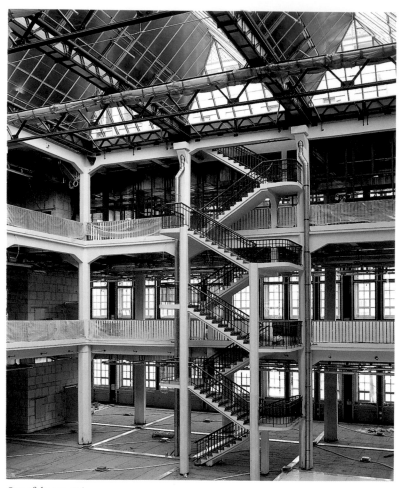

One of the ten atria

fore the former factory building was proposed as a possible site to house the new Center for Art and Media. Adapting an old building would certainly cost much less than building a new one, and the Center would have twice as much space at its disposal as originally envisaged.

On 16 June 1992 Karlsruhe City Council voted by a substantial majority in favour of adapting the old factory building. So the situation changed: the future site of the Karlsruhe Center for Art and Media moved from the south to the southwest of the city, to the area known as Beiertheimer Feld. The new institution was to be housed not in an exemplary embodiment of the late twentieth-century avant-garde but in a seventy-year-old monument to the industrial age.

A Former Munitions Factory becomes a Center for Art and Media

For a very long time, Karlsruhe's largest industrial building led a shadowy existence. Occupying the large rectangular plot of land lying between Brauerstrasse, Gartenstrasse and Lorenzstrasse, it formed part of a largely unattractive, if colourfully mixed, urban landscape made up of small businesses and allotments. After the building had been vacated in the 1970s, it was neglected. There seemed no longer to be any use for it; and it escaped demolition only because conservationists perceived its architectural strengths even in its delapidated state, and ensured that it be formally listed as an industrial building worthy of preservation.

The former factory building was, moreover, associated with an impor- tant, albeit largely forgotten, aspect of the history of Karlsruhe. As early as 1872, a weapons factory had been built on its site, and this expanded steadily until 1914. To meet the in- creased demand for weapons during the First World War, work on the construction of a new factory build- ing began in 1915. This, however, had barely been completed by the end of the war in November 1918; and, with the defeat of the German Empire, the factory was converted to serve peace-time needs. When the National Socialists came to power in 1934, however, the factory was soon restored to its former role. During the Second World War, the building fulfilled the military role for which it had been intended. After the end of the war, the factory again reverted to its peace-time role, largely supplying parts for the engineering industry.

Glass roof of one of the atria

The factory building, completed in 1918, had been recognized at that time as one of the most advanced industrial buildings of its type. Its architect, Philipp Jakob Manz, had made use of the latest building technology in creating a skeletal frame in concrete that took formal as well as functional requirements into account. In spite of its astonishing length of three-hundred and twelve metres and a breadth of fifty-four metres, the structure does not give the impression of being heavy or overwhelming in its scale. This is partly explained by its articulation into ten spacious atria.

In autumn 1992 the city of Karlsruhe commissioned four architectural practices to put forward their proposals for such an adaptation; and that presented by the Hamburg architects Schweger + Partner was preferred. This plan had one outstanding advantage: while retaining the distinctive character of the old industrial building, it nonetheless recognized and accommodated the absolute need, in such a case, for the greatest possible degree of flexibility. The 'rugged immediacy' of the original factory design gave the entire complex the atmosphere of a workshop that was especially appropriate to the aims of the Center. To begin with, eight of the ten atria were converted – four to house the Center for Art and Media itself, three for the Academy of Design and one for the City Gallery. The two remaining atria, at the northern end of the complex, are destined to house the Collectors' Museum administered by the Center.

One of the architects' principal concerns was that the emphatically spacious quality of the atria should be preserved as far as possible, bearing in mind that something of this would have to be sacrificed to accommodate large new structures such as the Media Theater. Within each of the atria, cantilevered stairways now link the various levels; and, in doing so, they symbolize the ideal of continuous and fruitful communication between the artists, scientists, and technicians at work on each of these. With regard, meanwhile, to the former factory building, the architects recognized that it should serve to connect one quarter of the city to another. 'Permeability' was the ideal here; and a passage through the seventh atrium from the north (the foyer of the Center for Art and Media) was therefore established to provide the desired east-west connection. Compelling solutions were also found for other problems. Because it would, for example, have been difficult to meet the technical requirements of the studios proposed for the Institute for Music and Acoustics, they were housed in a new addition – the 'blue cube'. Deriving its colour above all from its illumination, this structure serves not only to indicate the entrance to the Center; it is also an identifying symbol.

Construction got underway in earnest in 1993, and the roofing cere-

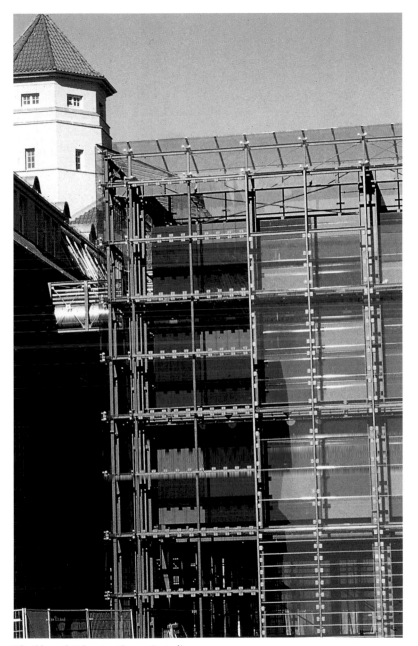

The 'blue cube', housing the music studios

mony was celebrated after only a year. Shortly thereafter the Academy of Design, provisionally housed in part of the city's green belt, was able to move in. The principal construction phase formally came to an end with the opening of the new Center for Art and Media on 18 October 1997.

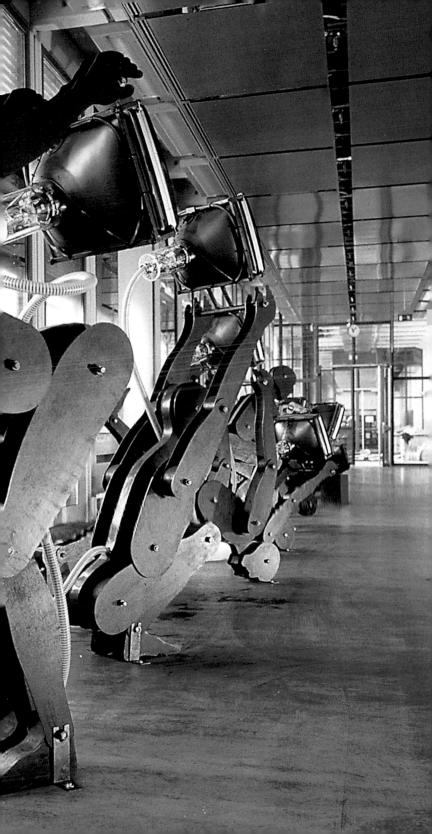

The Departments

The Center for Art and Media is divided into sections accessible to the public and an area that is reserved for staff, researchers, and other specially accredited visitors. The departments that are accessible during the usual opening hours are the two museums and the Media Library. Also forming part of the public area are the *Salon Digital*, the museum shop, and the restaurant. In addition, the Media Theater, the large music studio in the cube, various seminar rooms, and lecture halls are available for organized events appropriate to their size and facilities. The area closed to the public largely consists of the two institutes devoted to research into, and production of, new work – the Institute for Visual Media and the Institute for Music and Acoustics – and the offices of the Director and the administrative staff.

The Museums

The Center's greatest attractions are, of course, its two museums – the Media Museum and the Museum for Contemporary Art. These also take up the greatest surface area. The Museum for Contemporary Art occupies the entire ground floor of the eighth and ninth atria and also has at its disposal the temporary exhibition halls located in the tenth atrium. The Media Museum takes up the greater part of the first floor of the eighth and ninth atria, as well as a smaller section of the second floor. Together, the two museums offer an exhibiting area (including temporary exhibition space) of over seven thousand square metres. In addition, they have storage space measuring over 1,700 square metres. In 1999 it is hoped that the Museum for Contemporary Art will be extended through the addition of the Collectors' Museum, which will be housed in the first and second atria. With over 17,000 square metres of exhibiting and storage space, the Center for Art and Media will be the largest institution in Germany devoted to contemporary art.

The Media Museum

In establishing a Media Museum, the Center for Art and Media can claim to be entering new territory in many respects. With the exception of the InterCommunication Center in Tokyo and the Ars Electronica Center in Linz, the Karlsruhe Media Museum is the only institution in the world to be devoted to an interactive presentation of both the evolution and character of the new media and of their impact. To this end, a particular type of institution has been developed – one that is 'productive'. 'Productive' in this context means that the visitor will not

only find an assembly of pre-fabricated, self-sufficient objects, created out of artists' subjective obsessions. He or she will, rather, find artistic commentaries and visions, the intermediate stages in a process of discovery, in which artists, curators, and visitors all play a part.

Within the Media Museum, three networks have been established to interpret and present its founders' vision, each in a quite different way: these networks find their respective starting points in the *Salon Digital*, the interactive work stations, and the video trytograms.

The *Salon Digital* is the 'virtual' section of the museum and its gateway to the world-wide discussion forum offered by the Internet.

Interactive work stations encourage the visitor to experiment with media in a way that will allow him or her to become familiar not only with the foundations of media art, but also with the social impact of the media: the world of the computer game, the various concepts of cyberspace, computer-aided design, and so on. The largely unexplored possibilities of media technology are almost as new for the professional as for the lay person, especially in view of the increasing speed with which innovation follows innovation. Knowledge technological preconditions of garde media art is certainly a ry preparation for any meaningagement with such art.

Video trytograms, located throughout the Media Museum, contain statements by artists, curators' explanations and comments concerning the artistic and technological conception of the media installations, in addition to short animated sequences introducing all of the possibilities for interaction. (These are intended for those visitors who may require more thorough information).

The majority of exhibits included in the Media Museum's permanent display are, however, installations of varied sizes. These are examples of interactive media art that offer not so much an illustration of scientifically researched forecasts concerning the future of the 'information society', but artistically subjective, even ironic visions as to how our world will look if, for better or for worse, the revolution in communications technology continues at its present pace.

These installations have on the whole been made specifically for the space and the context in which they are presented as interactive environments. They have been conceived and constructed by artists, designers, scientists, and media specialists working in close collaboration, and can be divided into the following categories: Media Bodies, Media Spaces, Media Visions, Media Arts, Media Experiments, and Media Games.

Media Bodies

Concepts of the human body have continuously altered over the centuries, just as they alter from culture to culture. The body has been described, and very variously illustrated, as a part of the universe, the seat of the soul, or merely as a tool. With the creation of the first automata and the later invention of robot technology, the notion of the artificial man (or woman) has at least to some degree been transformed. In the interim the old debate concerning the 'natural' human body has itself been rekindled as a result of the development of gene technology and the capacities for simulation offered by the computer. The Media Museum shows the visitor how varied the idealized and fictional models of the human body have been in the past, and how our contemporary image of the body is being influenced by the new technologies, in particular by new techniques of simulation.

Jill Scott
Digital Body – Automata, 1997

Interactive environment

The relation between technology and the body has long been an important aspect of the work of the Australian media artist Jill Scott. With her *Digital Body – Automata*, this relation is viewed from a new perspective. This three-part environment, leading from the past, through

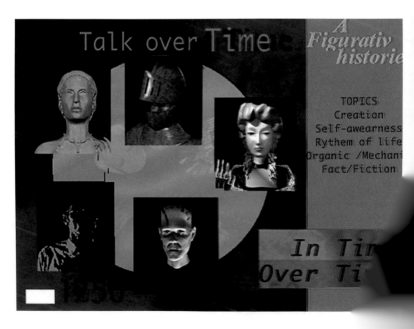

the present, to the future, demonstrates how the identity of the body is being endangered, how this identity is likely to be altered and distorted through the ever less restrained incursions of technology. In the first part, 'Figurative History', which relates to the past, Scott is concerned with

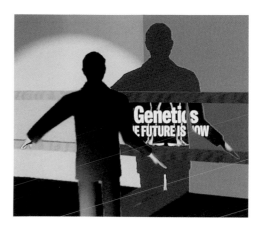

the automatization of the body. We encounter mechanical dolls, automata from earlier times – Lady Miso, a female robot from the eighteenth century, spiritedly playing the piano, Dr Frankenstein's monster, symbol of the manipulated man, the cyborg, a figure in knight's armour, a symbol of war. If these are touched, or if the spectators touch each other, the figures start to move or speak.

The second part of the installation, 'Interskin', is a game with the con-

cept of identity. A body (appearing on a computer screen) is lit from various directions. A digital stylus connects the viewer with the computer, which proposes a sequence of possible new existences, new experiences for the body, which is explained in terms of Western thought, then in terms of ideas originating in the Far East. In conclusion, various destinies and life histories are allocated to the body.

The third part of the environment, 'Immortal Duality', takes a none too

optimistic look into the future. Here, Scott is interested in the impact of biotechnology, in particular genetic research, with all its worrying associations, for example man's ceaseless quest to render the body immortal. The role of women in technological advance is also considered – here symbolized by the figure of Marie Curie as a robot in a glass showcase.

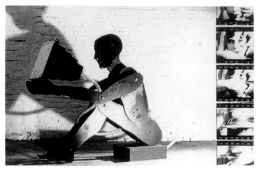

Frank den Oudsten
Floating Identities, 1995

Video sculpture

Floating Identities tells the story of simulation. Ten steel sculptures in human form support monitors, with video footage playing on their screens. The video sequences begin with the deconstruction of the human body during the Renaissance and end with the invention of the digital personality in the late twentieth century. Leonardo da Vinci's anatomical sketches contrast with a documentary record of plastic surgery, the movements of a ballet dancer with the serial photographic sequences made by Eadweard Muybridge (these last standing at the start of that great exercise in optical illusion that we call cinema). The video footage also embraces man's attempts to defy gravity, to leave space and time behind through flight. We see, for example, the various versions of Neil Armstrong's adventurous moon landing, his 'small step for man' looking as if it might have been devised in a Hollywood studio. *Floating Identities* shows how difficult the search for authenticity has become now that it is so often replaced by simulations and illusions.

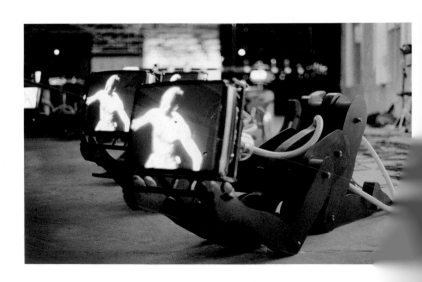

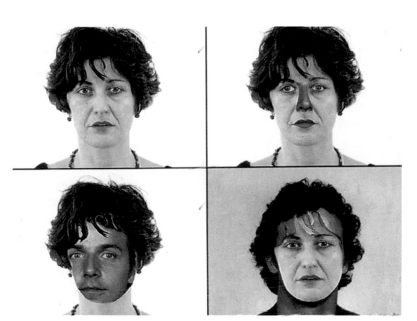

Alba d'Urbano
Touch Me, 1995
Interactive sculpture

Margret Eicher
After 'Corporate Identity II/2', 1994
Nach 'Corporate Identity II/2'
Copy collage

In this work Alba d'Urbano addresses the artist's desire to communicate directly with the spectator. The artist asks the spectator to touch her face (as it appears on a monitor screen), to feel her mouth, nose, and eyes. As they are touched, however, these parts of her face disappear, to be replaced by the corresponding parts from the video image of the spectator. The image of the artist becomes entirely taken over by that of the person 'interacting' with it.

The photocopying machine has altered the ways in which we communicate, as well as our concept of

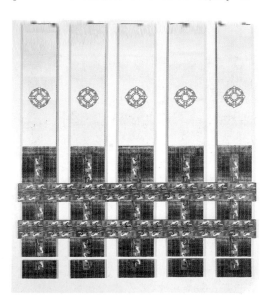

the 'original', like virtually no other medium coming into widespread use during this century. Margret Eicher makes the photocopier into both the thematic and formal starting point for symbolic sculptural structures. In her 'copy collages' the initial image is reproduced using the normal photocopying process, and then serially compressed to create an ornamental 'pattern book'. The work exhibited here uses a motif from Eicher's installation of 1992, *Corporate Identity II/2*, in which the 'copy collages' were developed into a sculptural ensemble. In the case of *After 'Corporate Identity II/2'*, the volumes are superimposed both horizontally and vertically and hung on the walls to cover an area of 3 by 2.75 metres.

Kirsten Johannsen
Skins, 1995
Häuten

Video sculpture

Kirsten Johannsen's reflections on the role of the body at the interface between the real and the virtual worlds elaborates imaginatively on the first line of an early nine-

teenth-century poem by Friedrich Rückert – 'Ich bin der Welt abhanden gekommen' [I am lost to the world] – that has survived, with all its Romantic sense of *Weltschmerz*, because it was set to music by the composer Gustav Mahler.

Devised as a prop for a performance recorded on video (during which a singer moved slowly through a deserted wood in allusion to Mahler's *Lied*), the video sculpture consists of a full body-suit made of black rubber, which has been reduced to a

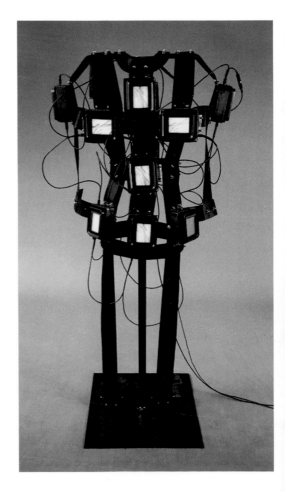

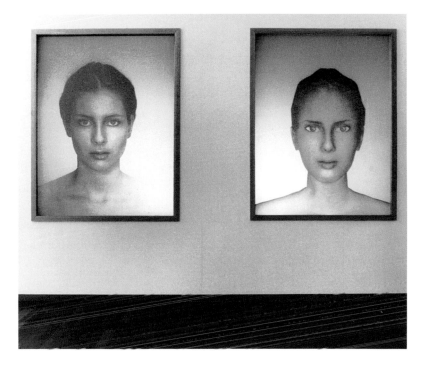

delicate framework on which small LCD monitors are mounted, the screen of each displaying close-up shots of the surfaces of human and animal skin. On stepping closer, the spectator hears the irritating hum of a mosquito on its fatal flight into the beam of light emitted by an apparatus for killing insects. Technology protects us from the world, but every such act of protection is also a small act of destruction.

Kirsten Geisler
Who are you?, 1996
Projection

Here, Kirsten Geisler juxtaposes the representation of the human body (which we have grown accustomed to describe as 'real') with its compu-ter-generated likeness (which we still tend to see as alien).

We see two portraits of the same young woman: one is taken with a video camera and at first sight resembles a large photograph, the other is a still more whit incompletely generated computerized image. The two faces gradually turn towards each other, look each other in the eye for a moment, then turn back towards the spectator. They then pose the question used for the title of this work: 'Who are you?'

Geisler thus prompts us to reflect on the various levels on which the concepts of reality and virtuality function. These are concepts that have a direct impact on the spectator, since it is to him or to her that the question is addressed.

Media Spaces

One does not need technology in order to plunge into the space of the imagination. Representing such a space in a picture, or simply in an individual's vision (sometimes with the help of meditation or even drugs), are ancient practices and familiar in most cultures. The verbal or pictorial description of the experience of such spaces has, indeed, a secure place in science fiction and in the visual arts. It was, however, only with the advent of computer technology that the simulation of real or imagined environments became possible. The creation of three-dimensional spaces that re-construct reality with photographic precision or that can be activated by the user him- or herself to construct what he or she has invented constitutes the true potential of contemporary virtual reality systems.

Especially fascinating in this context is the acoustic simulation of space. Painters and sculptors have always had to rely on merely visual strategies of representation; they could only aim at the human eye in their attempts to deceive through illusion. The multi-media director, by contrast, is able to accommodate all the senses within his own concept of space.

Pierre Dutilleux and Christian Müller-Tomfelde
Architecture and Music Laboratory, 1997
Interactive installation

Spaces alter the sounds that are made in them, be it an organ concert in a church, an orchestra playing in a concert hall, or words spoken from the podium in a theatre. The fact that each such space 'makes' a sound has great significance for human perception: we unconsciously grasp the size of an interior space in perceiving the small time intervals that occur between the sound reflected from the walls and the sound meeting our ears. In the *Architecture and*

Music Laboratory developed for the Media Museum by the Institute for Music and Acoustics, visitors can train their ears and experience the acoustic qualities of a variety of interior spaces. How, for example, would a song by the Beatles sound in a cellar, in a church, or in a cosy living room?

In virtual terms, it is also possible to make direct comparisons between several spaces in which the same music can be played. Some of these are familiar, while others are theoretical spaces based on regular geometrical bodies such as the cube, the cylinder, or the cone. Music is played, words are spoken, and simple sounds are made for the user to listen to; and, in each space, something different is perceived. For this installation, a synthetic resonance programme has been used that 'imitates' the acoustic of any given space. This was developed at the Institut de Recherche et Coordination Acoustique/Musique (IRCAM) in Paris, and goes beyond the scope and sophistication of the programmes used in recording studios. Sounds in real time can, for example, be 'shifted around' within virtual space. The stereophonic reproduction of particular sounds is also possible.

Thomas Gerwin
Sound Atlas, 1997
KlangWeltKarte
Interactive installation

We live in a world of sounds, rhythms, melodies and noises and collaborate in creating this everyday

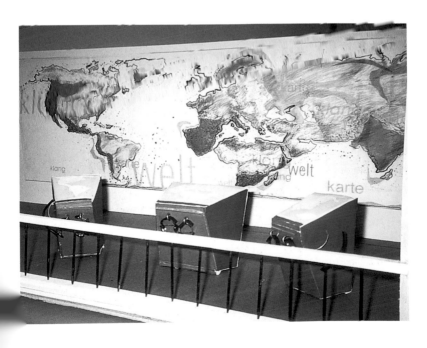

'symphony' through our own actions. In most cases, however, we lack the sensitivity that would be required to allow us to grasp this acoustic environment in all its complexity. The *Sound Atlas* is intended to sharpen our hearing and playfully to develop its capacity for perception. An interactive light and sound installation, the *Sound Atlas* consists of a wall display of twenty-four square metres, which shows an atlas in the form of an assemblage, and three tables with keyboards placed in front of it, at which the sound profiles of particular places can be called up. In total, the *Sound Atlas* contains sound profiles (compiled with the aid of computers) of one hundred and seventy-nine individual places, thirty-seven regions or zones, and all seven continents.

The sound profiles are acoustic portraits of the environment, based on recordings made in the places shown on the map. Some of these are packed with intriguing aural impressions, intended to evoke in detail a particular place or a landscape. In the case of regions/zones and continents, the sounds are first abstracted into sound events of a generalizing character. There is also a 'world sound', the murmur of the sea or the wind, that potentially conveys all frequencies, melodies, sound colours and rhythms simultaneously. One can listen to these sound profiles individually or hear several simultaneously. Everything is possible with this new instrument for 'musique concrète' – from 'natural' sounds to the most extreme examples of distortion or artificiality.

Jeffrey Shaw
Disappearance, 1993
Video sculpture

Jeffrey Shaw's video sculpture *Disappearance* may be understood to offer a timely, ironic commentary on the subject of virtual reality. A fork-lift truck, turning on its own axis, carries a television monitor. On its screen we see a ballerina. In reality, and as the spectator will soon discover, this is a greatly enlarged image of a miniature, toy ballerina that is actually hidden in the inside of the fork-lift truck. This figure is shown dancing about the same axis as that about which the fork-lift truck turns and is filmed by a video camera as it moves. The movement of the camera is synchronized with that of the fork-lift truck and, together with the video image on the screen, it constitutes the source of a 'closed circuit'. Shaw is playing here with our notions of 'real' and 'virtual' space and commenting on the theme of simulation through the distortion of dimension. While the 'real' ballet dancer is a miniature toy, her 'virtual' reproduction strikes us as gigantic. As Shaw demonstrates, the simulation of reality is only possible with enormous effort – the image of the doll is achieved by means of a highly complex technological system.

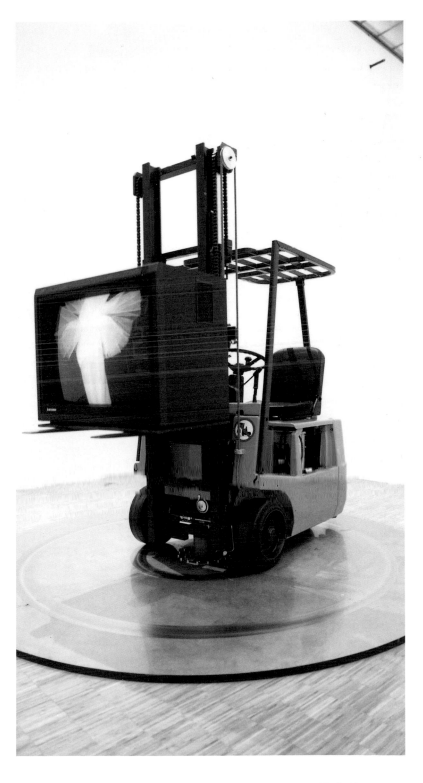

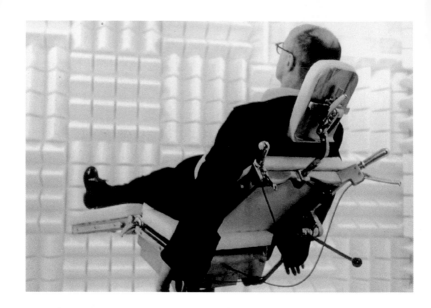

Rob Moonen and Olaf Arndt
Camera Silens, 1994
Environment

Here, we find ourselves in a dead quiet space. Cut off from the world outside with all its sounds, smells, and endless optical stimuli, we are suddenly thrown back upon ourselves. It is an unfamiliar experience for us to feel and hear only the movements and sounds produced by our own bodies – our own heartbeat or the sound of the blood rushing through our veins – and to be entirely exposed to our own thoughts and memories. Instead of the complete excess of stimuli that constitutes our daily experience, we encounter the total absence thereof. The *Camera Silens* in fact derives from experimental psychiatry. It was first used in 1970 for research purposes at the university clinic in the Eppendorf

district of Hamburg, as a therapy for varieties of addiction. Moonen and Arndt, who first developed their own 'silent chamber' as a sculptural work in 1994 at the Center for Art and Media, associated it with surveillance or solitary confinement – procedures that evoke memories of the high security wings of prisons. Such experiments with 'silent chambers' have, indeed, always been discussed in connection with the treatment of prisoners. At the Media Museum, accordingly, in the midst of multimedia installations and striking technological effects, the *Camera Silens* certainly represents something of a curiosity; but it is a curiosity that makes sense. It reminds us that no technological medium would have come into existence, were it not for the physiological and intellectual capacities of living people.

Media Visions

Books and newspapers, photographs and records, film and television – in short, the mass media – have long influenced our image of the world and worn away at our awareness of the dividing line between direct and mediated experience of this world to the point where we can no longer distinguish between them.

This development is accelerated by the seemingly unlimited possibilities opened up by concepts of the present and the immediate future that have been encouraged by media technology. Information superhighways, virtual reality, simulations or world-wide multi-user dungeons, are likely to be the arenas in which the new mythologies are played out. We do not even know precisely what the book, film, play, or even television programme of the future will look like.

We do, however, already have visions of this future. In the Media Visions section of the Media Museum we have, therefore, assembled a series of imaginative installations that allow the visitor to look into the future of the book, the film, or the play.

Jill Scott
Frontiers of Utopia, 1995
Interactive environment

Here, we meet eight women representing four different generations. For example, Mary, who lives around 1900 and dreams of a life in a socialist commune in Paraguay. Pearl, an Australian aborigine, a slave working on a settler's farm, longs for nothing but to be with her family again. Gillian, a hippy of the 'generation of 1968', places her hopes in the salvation of humanity through a communistic transformation of

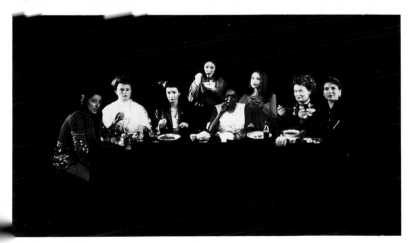

society. Zita, a media technician (and evidently the artist's alter ego), works at the salvation of our planet through the Utopia of cyberspace. These and the other four women tell us of their lives, their hopes, desires, ideals, and utopias. Each of them articulates an image of the future which the spectator may perhaps compare with visions of his or her own.

1990's Chanel 4

Moving forwards and backwards in time, the spectator is able to explore the lives of these women through documentary film footage, sound recordings, excerpts from feature films, and computer animation. He or she can also enter into direct dialogue with each of the women or invite some or all of them to a virtual dinner party and have them converse with each other – thereby ensuring a certain amount of mutual bewilderment, of the sort that often arises when people from different eras and social classes talk with each other. Objects too may be brought to life in this installation – personal memorabilia, documents relating to a particular era, souvenirs of the past.

Frontiers of Utopia is the concluding section of a three-part work on which Jill Scott embarked in 1991, with her *Machine Dreams*, and continued with *Paradise Tossed*. The female figures in *Frontiers of Utopia* are partly based on real people, for example the anarchist and feminist Emma Goldman (1869–1940); but they also draw on the artist's own thorough research and the interviews she conducted with women of various generations. From a technological point of view, *Frontiers of Utopia* combines traditional film footage with computer technology to achieve an exemplary form of a new genre – 'interactive film'.

Agnes Hegedüs
Memory Theater VR, 1997

Interactive environment

Memory Theater VR narrates the history of virtual reality as a cultural phenomenon. This is a history of the imagination as a mirror of the real world. The visitor plunges into an unusual theatrical setting, a bewildering, paradoxical game of fantasy and reality, in which fantasy may become reality and vice versa. It is a game with various spaces – real space, virtual space, and space where the user meets the machine, the interface. The starting point of the 'journey' is a (real) cylindrical space, the curved walls of which consist of panels of the sort found in conventional theatrical sets. In this space there is a video camera and an enormous canvas, and at the centre of the space there is a column with a miniature plexiglass copy of *Memory Theater VR*. The interface connected with this miniature model takes the form of a doll wearing 3D glasses and data gloves – symbols of the pioneering days of virtual reality. The doll functions as a camera, an eye exploring the virtual world. This allows the spectator to wander through the interior of the plexiglass model (in which real space is reflected) or to look at it from the outside (in which case the reflecting surface of the plexiglass model functions as a mirror of the virtual world). Alternatively, he or she can plunge into imaginary spaces and explore various types of fantasy worlds: worlds appealing to the imagination of a child (such as Alice's Wonderland), the worlds conjured up by artists (those, for example, of the Futurists, the Surrealists, or the Deconstructivists), the worlds evolved in science fiction novels, or the worlds invented by pioneers of virtual reality, such as Ivan Sutherland and Scott Fisher.

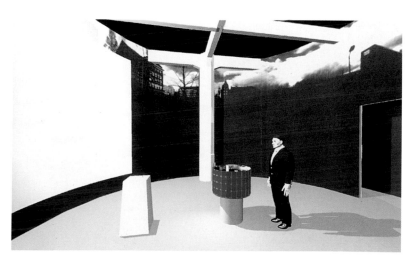

Bruno Cohen
Camera Virtuosa, 1996
Interactive environment

How are the new media changing theatre? The stage is the ideal place to explore the expressive range of the new media. As demonstrated by the *Camera Virtuosa* made by the French artist Bruno Cohen, the possibilities are almost unlimited. His miniaturized theatre invites the visitor to experiment. The era of the spectator as a merely passive consumer is over. Now there is no predetermined direction, no pre-ascribed roles, and no fixed points of view. Members of the 'audience' in this theatre 'move about' in every respect. They are not only spectators of the play they are watching, but potentially actors in it, even its director. They can move from the foyer to the box nearest the stage, and they can even act – in the form of their miniaturized reflection – on a virtual stage. They can intervene in the action of the play in progress, decide which actors should enter and exit, alter the set, sound effects, and lighting, and observe their own performances as virtual actors. As reality and its reproduction, real and virtual situations are superimposed, and clear distinctions between them disappear.

Tjebbe van Tijen and
Miloš Vojtěchovsky
Orbis Pictus Revised, 1995
Interactive installation

In 1658 the Bohemian Humanist Jan Amos Comenius published *Orbis Sensualium Pictus*, a book that sought to explain the world through

one hundred and fifty illustrated charts, each with a commentary. Comenius's motivating conviction was that concepts – even those as abstract as 'God', 'love', or 'death' – could be best understood if they were presented in an exemplary context. *Orbis Sensualium Pictus* proved to be an enormous success: it went through numerous editions and was widely imitated. Even today the underlying principle of Comenius's volume survives in many an illustrated dictionary. Tjebbe van Tijen and Miloš Vojtěchovsky took Comenius's idea and extended it in the form of an interactive installation.

Orbis Pictus Revised shows how people over the centuries have

sought to explain the world as they have conceived it through images, and how the significance of their concepts and that of the images used has also altered over the course of time. From a virtual bookcase, the user can call up various editions of Comenius's *Orbis Pictus*, and of later illustrated dictionaries. Here, he will discover the ingenious conceptual system, presented in cosmograms and tableaux. The visitor can trace, for example, how the image of 'the world of work' has changed over the centuries, from the farm to the large industrial concern of today. Equally interesting is the change in associations: the phrase 'feeding the baby', initially illustrated by the image of a large family or a wet nurse, is in the twentieth century symbolized by the image of a baby's bottle.

In another section of the installation, various objects are laid out on a table. When the visitor picks up one of the objects, the image representing it in the original *Orbis Pictus* appears on the screen, accompanied by examples of the way it has been verbally

defined from the seventeenth century until today. The visitor can thus ascertain the relative importance such an object may once have possessed within man's former image of the world and compare this with the perhaps quite different significance that such an object may now have.

Masaki Fujihata
Beyond Pages, 1995
Interactive environment

Here, the spectator can browse in a virtual book that is projected on to the surface of a ('real') table. If one touches the pages with a special

stick, they will 'turn' with a rustling sound. Various projected objects then appear on the pages of the book, all of which alter their shape or emit sounds when touched: fragments of Japanese text are simultaneously seen and heard; the leaves on a branch are seen to move back and forth as if in a breeze. The 'reader' sets off even more astonishing effects when he or she clicks on the image of a switch and the handle of a door: a light is turned on in the real space that he or she is occupying, the image of a door is projected on to the wall, appears to open and then close again rapidly, accompanied by the laughter of a child who briefly pops its head through the opening. Fujihata's work offers a futuristic and entertaining commentary on how 'the book' might look in the future: it will be able to speak with (not merely to) its 'reader' and alter his or her environment in a vivid and striking fashion.

Media Arts

Artists have now been engaging with the interactive possibilities of the new media for over fifteen years; but this new field, even though it seems more than likely to be recognized, in time, as *the* avant-garde of the end of the twentieth century, has so far acquired no secure place in the 'world of art'. Because examples of interactive media art have predominantly been seen as occupying a place outside the 'official' art scene, the manifold tendencies, styles, and schools that have already emerged have barely impinged on the awareness of those with an interest in the arts. As a result, both the general public and art critics have a distorted image of the media arts. As a first step towards rectifying this situation, the Media Museum displays a number of the most important examples of this type of art, which has evolved over less than two decades. Our 'Interactive Art Gallery' allows viewers to make comparisons, to develop aesthetic criteria, and to explore the effect of these works of art – all of these being essential prerequisites for assessing artistic value.

Lynn Hershman
Lorna, 1979-84

Interactive environment

Lorna is generally regarded as the first autonomous work of interactive media art. Hershman presents a wo-

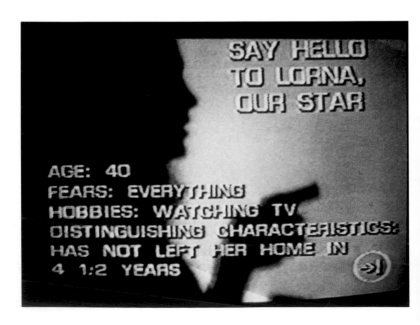

York, depending on his or her choice. The city's buildings consist of computer generated letters that combine to form words and sentences. In each case Shaw uses texts that have a direct connection with the history of the city concerned. The excitement in this work for the viewer is derived from the contrast between the real and the virtual world. The visitor sits on a real bicycle and travels through a virtual space; but this virtual space – at least if the cyclist knows the city - prompts associations with historical reality. While the cyclist travels through the legible city a new image of this location forms in his or her mind. Shaw's

man whose world has shrunk to the size of a television set. Using a remote control device, the viewer calls up various channels from an interactive video disc, and is thus able to observe Lorna engaged in various activities in her insulated living space. Depending on how the viewer moves through the channels, three different endings to Lorna's story are possible: Lorna switches off her television, Lorna kills herself, or Lorna leaves her prison and acts off for Los Angeles.

Jeffrey Shaw

The Legible City, 1988-91

Interactive installation

Here the spectator sits on a fixed bicycle and 'travels' through a simulated city – Karlsruhe, Amsterdam, or New

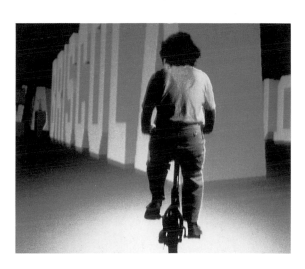

Legible City, a classic of interactive media art, evokes the quasi-corporeal manner in which we penetrate cyberspace – here not rendered in photorealistic terms, but described poetically with the textual structures of real history.

Luc Courchesne
Portrait no. 1, 1990
Interactive installation

The interactive installation *Portrait no. 1* invites the viewer to talk with a young woman, Marie, whose face appears on a monitor screen. The viewer selects various questions and subjects from a range offered to him or her and thus enters into contact with this virtual interlocutor. The conversation can be conducted in French, English, Italian, Dutch, or Japanese. A conversation with a

computer programme that has a face and a name, reveals the fascination, if also the limitations, of 'humanizing' the machine – a preoccupation of artists since the era of late eighteenth-century Romanticism.

Ken Feingold
Surprising Spiral, 1991
Interactive installation

A large, hollowed-out book lies on a pedestal. Within the hollow we find wax casts of the hands of an adult and a child. The cover of the book is a transparent screen that is sensitive to touch. Touching the finger prints found on the screen sets off sounds or a voice reading text. Film of landscape and people are projected on to the wall and are related, by words being superimposed over them, to extremes of experience: love, death, desire, and terror. While the spectator controls the alternating sequence of film footage and texts, no pre-programmed sequence of these is detectable. The sequence is determined purely by the spectator's previous experience. Alongside the large book there lie a number of smaller volumes, among them *The Monkey*

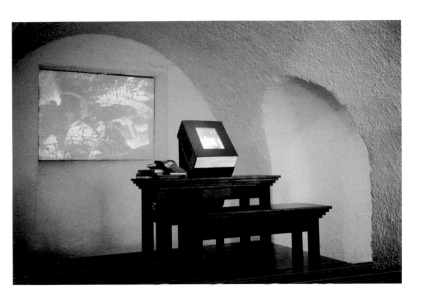

Grammarian by Octavio Paz, with an image of parts of the mouth on its cover. If the lips are touched, one hears text from the book, but this is then drowned out by the sounds accompanying texts projected on to the wall. Here Feingold addresses the fruitful and sometimes also frightening competition that exists between image and word, from the teachings of the Jewish Kabbala to the amateur video of the late twentieth century.

Agnes Hegedüs
The Fruit Machine, 1991
Interactive installation

Artists have been drawn to games for as long as art itself has existed;

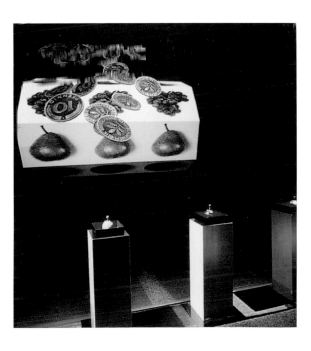

but the strategies involved in game playing are of particular significance for interactive media art. This is partly because it is, above all, from video and computer games that the interfaces that artists and their public have to negotiate, have evolved. It is also because our experience at the interface between games and art is important for our evolving abilities to engage with the new media. *The Fruit Machine* is a work of art that allows the spectator to explore the interactive strategies of game playing. It recalls a machine designed for playing games but one which is, nevertheless, not suited to such a purpose. Everything depends, rather, on the cooperation and skill of the other players. The 'playing field' or 'game board' here is a geometrical shape divided into three parts. These parts can be moved and controlled by three players by means of a joystick. The surfaces of the geometrical shape depict various fruits, and it is possible to coordinate the three images visible at any one time so that all show the same fruit. If the players

are successful in putting the fragments of the geometrical shape together, a virtual shower of gold coins appears as their reward.

Michael Naimark
The Karlsruhe Moviemap, 1991
Interactive installation

Nowadays, computer-generated images are usually employed to create virtual space. At an earlier stage in technological development, however, similar ends were achieved through the use of so-called 'moviemaps': these were filmed city maps through which the visitor could 'travel' in real

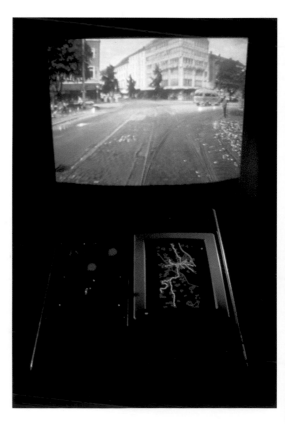

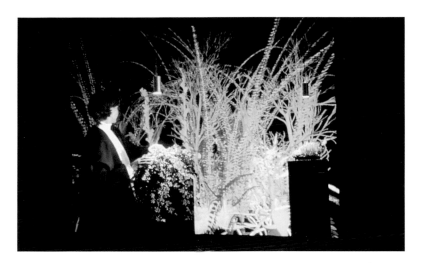

time. Michael Naimark's project is the third attempt at creating this type of 'moviemap', and was inspired by the preceding attempts made at the Massachusetts Institute of Technology (MIT). To simulate a tram journey through Karlsruhe, the entire map of the city's tram routes was recorded on video. The 'traveller' controls the speed of the film with a lever. At each point where one tramline crosses another and a change of direction is possible, the next tramline section is chosen by selecting from a dial located on a dashboard, and the virtual tram journey continues accordingly.

Christa Sommerer and
Laurent Mignonneau
The Interactive Plant Growing, 1992
Interactive installation

Here, the spectator can become a 'creator' and make plants sprout. By touching the leaves of real plants he sets off the growth of over twenty-five computer-generated virtual plants. The computer reacts to the drop in electric potential between the surface of the plants and the skin surface of the spectator, which varies from individual to individual, and is also affected by factors such as duration, even though this is barely perceptible to a human being Depending on how the real plants are touched, the image of the virtual plant can be altered. If the spectator dares to touch the cactus, all the plant life suddenly disappears, giving way to the infinite blackness of the realm of virtual possibility.

This installation takes as its theme one of humanity's oldest dreams: to be able to create as nature does. A particularly interesting feature is that physical contact between the human and vegetable realms in real space is a precondition for ordering the machine to generate new life or to destroy it.

Frank Fietzek
Chalkboard, 1993
Tafel

Interactive installation

Slate is an interactive computer-controlled wall installation that very variously interrelates three notions: the act of remembering, human memory, and computer memory. A monitor, attached to both horizontal and vertical rails, is placed in front of an old chalkboard, on which it is still possible to make out the traces of largely erased chalk marks. The monitor can be moved, by hand, horizontally and vertically across the surface of the slate. As it is moved, hand-written notes appear on its screen, although these are not related to any particular area of the chalkboard. Each user can em-

ploy the monitor texts in an attempt to decipher the meaning of the half-erased chalk marks and so to reconstruct the text that might originally have appeared on the slate.

Grahame Weinbren
Sonata, 1993
Interactive installation

Sonata is a form of interactive cinema. Scenes based on Leo Tolstoy's novella *The Kreuzer Sonata* are combined with elements from the Biblical legend of Judith and Holophernes to create labyrinthine sequences of images. The logic of a linear cinematic narrative structure is thus suspended. The visitor can in-

fluence or alter the course of the film by reaching for the suspended frame that controls the narrative by way of infra-red sensors. The same scene, for example, can be played out from the point of view of several different characters, and the outcome of different strands of the narrative can be pursued. Weinbren's interactive cinema re-unites two usually strictly divided entities – the artist's intention on the one hand and the viewer's interpretation and associations on the other – to create what is effectively a new medium: the non-linear film narrative.

Bill Seaman
Passage Sets / One Pulls Pivots at the Tip of the Tongue, 1995

Interactive installation

This interactive installation made by the Australian artist Bill Seaman offers the visitor the possibility of gaining experience of his or her own in creating a work that goes beyond the banal associations of the term 'multi-media' as understood by 'media practitioners' with an eye, above all, on speedy profit. The visitor is able to control the projection on to three large screens of words, poetry, images, spaces, and sounds, and to relate these or separate them, and to devise a continuous sequence of juxtapositions between them.

By this means the triptych is revitalized, offering new scope for both static and moving pictures and the incorporation of language. This allows users to embark on imaginary journeys between spheres that are strictly separated in traditional art. One uses this 'art machine' to explore the associative potential of the multi-media 'total work of art'.

Media Experiments

Such a new, indeed as yet barely developed, area as media technology is, by its very nature, a field of experimentation: for experiments carried out by technicians, by scientists, by artists, but also by non-specialists.

All of us in the industrialized, even semi-industrialized, societies of the late twentieth century, have daily experience with the new media technology and are thus aware of its possibilities, even though we may not bring the sophistication of scientists or the insights of artists to our musings on this matter. The Media Museum accordingly makes available to the visitor various installations that allow him or her to explore the latest developments in media technology.

It goes without saying that this part of the Media Museum will alter as the installations it embraces are altered and as new installations are added. Those described here are thus to be regarded as 'prototypes' – and in the best sense of the word. This section of the Media Museum will develop in a way that reflects the evolving understanding and responses of its visitors.

The Salon Digital

The salons of the eighteenth and nineteenth centuries were the site of heated debates, the plotting of revolutions, the exchange of ideas about art, and the birth of theories that both anticipated and spurred future innovations. The Media Museum's *Salon Digital* recalls the highly developed salon culture of the past and revises it by finding for it a form appropriate to contemporary society. The *Salon Digital* is a symbol of the communication culture of the twenty-first century. Far more than

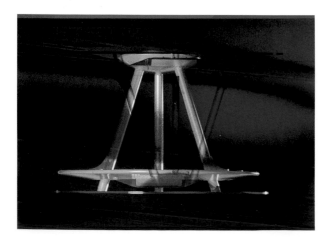

through the Media Museum and inspect its various spaces and exhibitions.

Other virtual 'tours' will also be on offer – through a virtual museum of architecture, or through the excavation site at Çatal Höyük in Turkey. The Australian artist Jill Scott has designed a 'Virtual Sculpture Garden' for the *Salon Digital*. This takes the form of a three-dimensional puzzle,

is the case with the Internet cafés of the 1990s, the *Salon Digital* is intended as a forum for discussion relating to new technologies.

Its specially designed terminals offer visitors to the Media Museum access to the Internet, while net servers allow those elsewhere to access the *Salon Digital*, and thus the Media Museum as a whole. A regular programme of events will be organized by guest curators – artists and scientists – and those visiting the *Salon Digital* website will also be invited to take part. The *Salon Digital* will make available on the Internet constantly updated information about the Center for Art and Media – concerning the current displays, the holdings of the Media Library, and events at the Center for Media. Those visiting the *Salon Digital* website can 'walk'

the individual sections of which, when correctly combined, reproduce the landscape of the Rhine flood plain near Karlsruhe. The segments of landscape are stored in the *Salon Digital* net server. From here artists can download them, using the Internet, into their own computers and then integrate into them the visual and sound sculptures they have themselves devised. The evolving result of these artistic inventions is the 'Virtual Sculpture Garden' through which virtual visitors can stroll.

Michael Krause
Virtual World Machine, 1997
Virtuelle Weltmaschine
Interactive installation

Idealization, simulation, and construction, all important qualities of

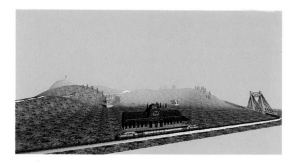

tear along at the high speed of a modern Inter-City Express. He can also decide what sort of weather and time of day he prefers, and simulate these – rain and thunder, sunset or sunrise, or a clear night sky full of stars. In yet another illusory world, the visitor can make his own decisions regarding the characteristics of the space through which he travels. As a crane operator, he can re-arrange its three-dimensional geometrical 'building blocks' and thus become the architect of his own environment.

virtual space, are illustrated in this installation. The visitor is here enabled literally to 'experience' the concept of a 'perfectly' virtual world by travelling through it. Equipped with a joystick, he or she travels through worlds of illusion that can be altered to suit individual moods and requests. As a result of the interactive possibilities encountered within this world, the user can experiment with three important characteristics: choice of personal location, manipulation of the virtual laws of nature, and direct alteration of virtual spaces. To begin with, the visitor moves through an idealized miniature world of model railways. A 1950s Transeuropa Express speeds through an immaculate artificial landscape. This blessed realm can be observed from a variety of positions and perspectives. The visitor can get up close to the engine, or drive it himself, or even have himself run over by it. In the 'world of situations' the visitor can sit in the engine driver's seat and drive around a miniaturized globe. He can decide if he prefers to travel relatively slowly, at the speed of a steam train, or to

Laboratories

In order that computer technology does not remain a book with seven seals, with results that the majority of people only learn about reluctantly and anxiously, or merely marvel at in a purely passive state, the Media Museum has set up laboratories in which the visitor can acquire his or her own experience of the new media. There are several contexts in which the visitor can conduct small experiments, the aim being to help him or her understand the latest technological developments in as far as these are likely to have an impact on professional, social, and cultural life. Among the areas to be introduced in this way are digitalization

and the function of sensors, programming and modelling, the computer control of movement, and image reproduction. How, for example, does a fax machine work? How does a computer generate sound? How are the images produced by a CD-ROM or those found on a television screen made? Such questions are answered here in a playful spirit.

A great many of the installations in the Media Museum demonstrate that virtual space can expand the horizons of our experience. In the laboratories the technological basis of virtual space is explained. The visitor will learn how photorealistic views emerge out of a vast mass of digits, and will be introduced to the vast range of possibilities offered by the use of virtual space. Elsewhere, the visitor can learn something of how voice-mail and the Internet function, how computers 'talk' to each other, how data is bundled, and how it is transferred using light. It is often a case of small causes issuing in enormous consequences – and consequences that are not always positive. Computer errors can have disastrous results: satellites stray from their pre-programmed orbits, car manufacturers have to re-call their products, telephone bills fail to add up. The Media Museum laboratories also allow the visitor to test out his or her own skills as a computer detective and to track down the source of the most notorious computer errors.

Onno Onnen
Mechatron 10/11, 1993
Experimental arrangement

The robot installation *Mechatron 10/11* offers an especially poetic commentary on the subject of 'artificial' intelligence. The 'limbs' of a small machine are set in motion by motors. An image is projected on to a screen and microcomputers control each action and reaction: the machine crashes into the wall, rebounds, appears taken aback, and tries again. The projected image of the machine reacts, appears to modify its behaviour and its strategy and thus to 'learn' from experience. The impression that the machine is alive depends entirely, however, on the spectator, who can hardly help but associate the computer-controlled movements of the machine with human behaviour.

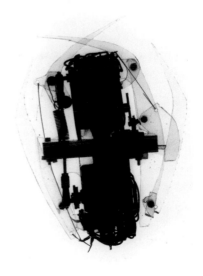

Media Games

Since 1974, when the first home computer game appeared on the market, video and computer games have come to occupy a prominent position within our media culture. In view of their economic significance and their contribution to technological innovation, they have far outstripped other types of mass media. However, as society as a whole has become aware of both the opportunities and the dangers signalled by the new media, video and computer games have come under fire from critics of various persuasions.

The World of Games

The section of the Media Museum called the *World of Games* seeks to introduce visitors to the history and mechanisms of computer and video games. Various concepts of the 'game' are analyzed and critically explored. To what extent, for example, do computer games reproduce social reality? What clichés regarding social roles do they help to strengthen? What can they offer in terms of models for the solution of conflicts? How much importance does violence assume in such games? No questions (or their various answers) need remain merely theoretical, for they can be tested by the visitor. One installation, for example, focuses on the banned cult game 'DOOM', which is uniquely committed to the breaking of taboos. While in the original version of this celebration of violence, the player is placed in a position of power, in the version presented at the Media Museum the visitor finds himself to be the potential victim: he sits in a dentist's chair and, while he plays, a miniature camera records his facial expressions and gestures. The player can then call up this recorded visual data.

The installation *License to Kill* (recalling a multiple rocket launcher from the Second World War) also addresses the sub-

ject of violence in computer and video games. Here, virtual and real scenes of violence are juxtaposed – the assassination of John F. Kennedy and a sequence from the currently popular game 'Duke Nukem 3D'. This offers a compelling demonstration that reality is incomparably more cruel and brutal than the staged violence found in games.

The range of roles offered by computer games is exceptionally small. Male characters – inevitably the leading figures – are generally heavily armed fighting machines and dazzling, youthful warriors. Female characters, only ever of subordinate significance, are helpless princesses or long-haired temptresses. The installation 'Lone Wolves and Beautiful Brides' seeks to sharpen the visitor's awareness of these stock roles. It is, of course, true that computer games do not so much introduce new social roles as draw on a rich store of symbols relating to deep-rooted cultural traditions. This equally intriguing aspect of computer games is addressed in the *World of Games* section of the Media Museum. Video and computer games are also shown to have more in common with the age-old game of chess than is usually realized. Computer games that have long been recognized as 'classics', and have in many cases now become cult objects, are also presented. This section of the Media Museum also presents an entirely new game, 'Labyrinthos' specially devised for visitors.

The data bank 'Search & Play' is intended to help the user find his way in the confusing mass of computer games that is now invading the market. Here, the visitor can find out about computer games that are currently available. 'Search & Play' is also accessible on the Internet; and it is available on CD-ROM.

The Museum for Contemporary Art

On its foundation, the Center for Art and Media was intended to embrace a Museum for Contemporary Art. Since 1990, therefore, a comprehensive collection of contemporary art has been amassed. The programme of the Center for Art and Media, with its focus on media technology and the possibilities offered by electronic data processing, was also committed from the start to ensuring that the collection of new art was not limited to the classical categories (notably, painting in oil on canvas, sculpture, and print-making), but that it should also embrace 'technological images' (photography and video installation in all their manifestations), and that these should be equally central to the public display of contemporary art.

The museum now owns one of the largest collections of media art in existence. This embraces work from the early days of video, classic examples of electronic installation, and even holography. In addition, a further one thousand two hundred art videos are available to view on request in the Media Library. Because the goal has always been that of a 'museum for all the arts', it has been essential to focus visitors' attention on the new forms of art without distracting them altogether from the 'classical' categories. In the following pages we therefore begin by discussing examples from the museum's collection of paintings.

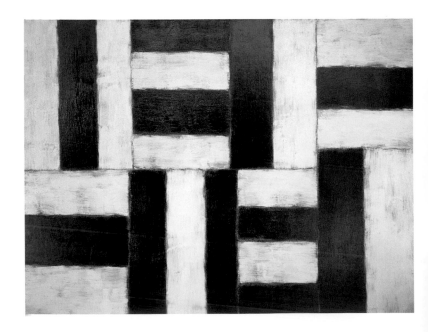

Painting

Contemporary German art is well represented in the Center for Art and Media. There are also outstanding examples of painting by other Western European and North American artists, such as the expatriate Irish artist Sean Scully, the Dane Per Kirkeby, the Swiss artists Urs Lüthi and Helmut Federle, or the American Robert Rauschenberg.

Sean Scully
Light in August, 1991

Oil on canvas in three segments
Upper left: 114 x 228 cm
Lower left: 114 x 228 cm
Right: 229 x 76 cm

This work by Sean Scully is an example of one of the main tendencies to be found in contemporary painting – the renewed interest in varieties of abstraction. Scully's paintings confront the spectator with a rigorous geometry. This, however, is not rendered in precisely outlined shapes but, rather, so as to allow the artist's individual 'handwriting' to remain detectable. It is this quality that distinguishes the 'new abstraction' from the 'cold' planes of colour found in the work of artists such as Victor Vasarély

or Max Bill. Smooth perfection and precise out-line are no longer the qualities at which the artist aims.

Georg Baselitz
Blondes another Place, 1992

Oil on canvas
290 x 290 cm

Georg Baselitz, most readily associated with paintings in which figures are shown upside down, has recently turned to Neo-Abstraction. This

new declaration of faith in the non-objective and in forms independent of any direct relation to reality is all the more surprising in that Baselitz previously always claimed to see an advantage in retaining a certain tension between abstraction from, and a rendering of, natural appearances. In recent abstract work, as in the past, however, he still emphasizes the painterly application of paint, that is to say, the individual 'handwriting' visible in each painted form. The geometrical arrangement of the shapes one finds in such work is questioned by the looseness with which the overlapping dabs of paint are applied. The composition is not approached as if it were an arithmetical problem; there are no outlines that appear as if drawn with a ruler, no shapes calculated to the exact centimetre. Geometrical abstraction here returns to painting as a sort of anti-geometry.

Per Kirkeby
Untitled, 1989
Oil on canvas
300 x 500 cm

This large painting by Per Kirkeby was the principal work that the artist exhibited at the Venice Biennale of 1993. In contrast to what one finds in the work of Scully or Baselitz, the colour planes here stand in a loose relation to each other, and no attempt is made to imply a strict geometrical arrangement. Rather, as is so often the case in Kirkeby's work, allusions to reality are retained. This particular painting prompts memories of landscapes, fields, forests, clouds, and horizons. We find that these have been 'translated' into a subtle, coloured arrangement in which reference to objects in the real world is still suggested, if not clearly explicated.

Albert Oehlen
Untitled, 1993
Screen print and acrylic on canvas
250 x 400 cm

Helmut Federle
Untitled, 1990
Acrylic on canvas
280 x 420 cm

With his large abstract works, Albert Oehlen relates to quite another context – to computer print-outs of geometrical calculations. With this large picture on canvas, however, Oehlen has left behind the often minutely detailed patterns of computer graphics and has evolved an autonomous language of novel symbolic associations.

Helmut Federle has placed the shapes of geometry – a circle and a u-shaped open rectangle – in a tense relationship to each other. By this means, he alludes to the deeper significance to be found in abstract forms. While it would be impossible to say what precise idea is expressed

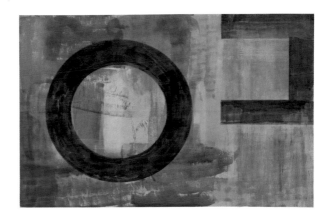

here, associations with a mythical background are irrepressible. The striated coloured background, applied in a painterly fashion, bestows a considerable sense of depth on the precise shapes of geometry and redeems them from the visual 'superficiality' of appearing merely two-dimensional.

Günther Förg
Untitled, 1992
Acrylic on lead sheeting mounted on wood
180 x 110 cm

Günther Förg too belongs among the now large group of Neo-Abstractionists. He continues the tradition initiated by Barnett Newman, personally appropriating Newman's ideas and further developing them. Förg's geometry recalls Newman's expansive gestures, his means of reaching for what he termed the 'sublime'. Förg has transformed Newman's legacy, however, in painting on lead sheeting so that the irregularities of the metal surface remain detectable through the thin layer of paint. In sharp contrast to this approach, however, are the emphatically hard-edged strips vertically dividing the picture.

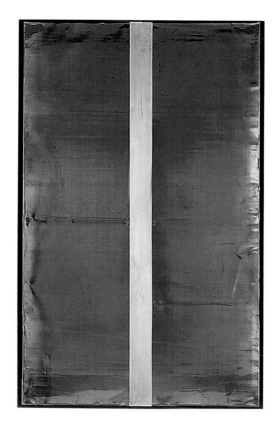

Markus Lüpertz
Poussin – Philosopher, 1990
Oil on canvas
200 x 300 cm

This work stands in stark contrast to examples of Neo-Abstraction. While still qualifying as figurative painting, it may almost be said to re-invent the forms of Abstraction or to appear to treat them as part of a larger system

K. H. Hödicke
Flag, 1985
Artificial resin on canvas
200 x 300 cm

The Berlin painter K. H. Hödicke does not shrink from engaging directly with contemporary reality. In 1985 he painted the Reichstag building in West Berlin with the flag of the German Federal Republic flying over it. In the picture shown here the 'Land of Brandenburg'

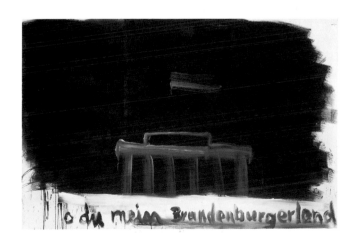

evoked in the added lettering seems as if it might be a line from a traditional song of lamentation. In the painting's bold brushwork objectivity re-appears, albeit in a new form, as if the artist were convinced that reality had to be re-created with paint.

Urs Lüthi
Hope, Despair, 1989
Acrylic on canvas, wooden frame
210 x 160 cm

The work of the Swiss artist Urs Lüthi, like that of Hödicke, offers an example of the increasing tendency, in contemporary painting, for words to be incorporated within images. Lüthi places the words 'Hope' and 'Despair' in his picture with classical austerity. He thus transforms the geometry of the cross into the deeper significance of a form mediating between a black horizontal bar of despondency and a yellow vertical beam of optimism.

Sigmar Polke ▷
Drum Picture, 1992, summer
Artificial sealing wax and liquid artificial resin on polyester fabric
280 x 388 cm

In some of his latest pictures, Sigmar Polke has distanced himself much further than in the past from all literary content and meaningful allusion. Across the translucent surface, through which the vertical, horizontal, and diagonal slats of the

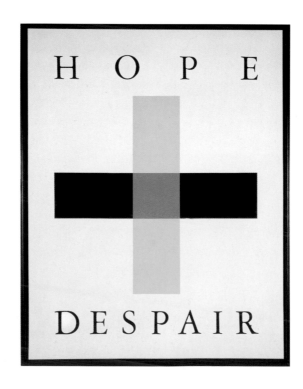

wooden stretcher can be detected, the colours spread like essences, variously forming fluent planes, dried spots, and nervous lines applied with the point of the brush. These are marks that appear so diversely eloquent and yet say nothing, that gesticulate meaningfully and yet are empty of meaning. Polke's picture is a pure game with colour, pure abstraction. In short – an autonomous image.

Dieter Krieg
Untitled, 1995
Acrylic on Plexiglas
95.5 x 264 cm

Dieter Krieg's principal subjects and concerns are incidental everyday objects and the banality of our interaction with them. His fried egg, two and a half metres in breadth, is one of those trivial and inexpressive objects that have never been painted before and that never would have

been painted if they had not come so close to a complete absence of meaning. As in the early work of Markus Lüpertz, Krieg's pictures allow objects that are of minor importance to take on monumental proportions, so that they may serve as the starting point for powerful colour compositions. Krieg's fried egg is an orgy of colour, but at the same time an act of violence against the object itself. This is a work that seems to show us that objective painting is still possible only at the very edge of possibility.

Nam June Paik
Time Runs / Tape Runs, 1984
(From the portfolio **V-IDEA**, from an edition of 58)
Etching
Image: 30.5 x 38 cm
Sheet: 47.3 x 54.6 cm

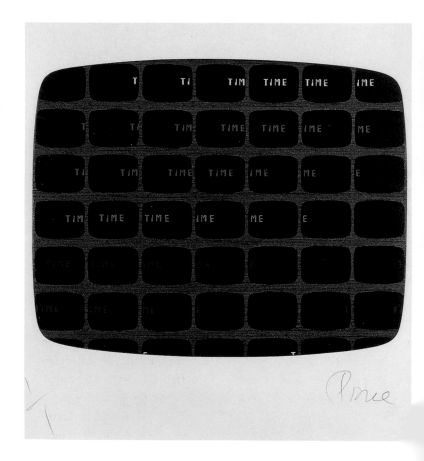

Nam June Paik
TV Story Board, 1984
(From the portfolio **V-IDEA**,
from an edition of 58)
Etching
Image: 30.1 x 38 cm
Sheet: 47.9 x 54.1 cm

The appealing prints made by this Korean artist, a founding figure of media art, also oscillate between objectivity and abstraction. Yet, the overall format leaves us in no doubt as to the significance of form here: for the outlines we see are those of a television monitor, implying that all images have now, to some degree, become images encountered on a screen. The print *Time Runs / Tape Runs* functions like the freezing of a moving strip of lettering that conveys to us the latest news but that always ends up ruptured and tattered by the time it reaches the side of the screen. Yet the pixel-like pictorial units incorporated within the overall picture, are themselves monitors with time elapsing. *TV Story Board* consists of faces, eyes, breasts, and mouths, between which we glimpse Korean written characters that are transformed into little human figures. Here then, even the 'story board' – the basic narrative of a filmed story – becomes a universal monitor screen. Television is omnipresent. Paik, one of the inventors of video art, here assumes an ironic position towards the medium he has made his own.

Photography

Unlike painting, photography almost by definition retains a certain relation to reality. Because it seemed to many that this relation could only be a documentary one, photography was only slowly and reluctantly granted the status of an 'art'. During the last three decades the situation has changed, and photography has been recognized as an 'art'. At the same time, the range of its creative possibilities has increased, with the prevalence of the staged photograph being the best example of this development.

Teun Hocks
Untitled, 1988

Hand-coloured photograph
103 x 141 cm

In preparation for this photograph, the Dutch artist Teun Hocks arranged a scene that appears to come straight out of dreams and imagination. Yet, as a photographic image, it nonetheless asserts a claim to being a record of reality. A giant from some fairy tale or other is about to drop a bomb on an idyllically illuminated little house standing in a wide plane. As the next item shows, however, it is by no means only 'staging' that makes photography into art.

Andreas Gursky
Union Rave, 1995
Colour photograph
(no. 4 of an edition of 6)
164 x 275 cm

This segment of an evidently large, excited crowd of people is the result of a selective view that transforms a mass of human figures into a sort of human carpet, in the seemingly endless surface of which the individual almost disappears. Andreas Gursky's work as a photographer tends, as a rule, towards the production of extremely detailed images, within which the individual unit, even the individual human figure, is itself reduced to insignificance.

Barbara Kruger
Who will write the history of tears?,
1987
Bromide silver photograph, screenprint text, framed
246.5 x 104.4 cm

Barbara Kruger's photomontages stand in contrast to Gursky's detailed panoramas. Here, the photograph appeals to the viewer in the manner of a poster, incorporating letters and words as elements that are crucial to its intended effect.

Marie-Jo Lafontaine
The Angst, 1988
Black-and-white photo-
graph, oil on wood,
bronze lettering
160 x 130.5 cm

Like Barbara Kruger,
Marie-Jo Lafontaine in-
corporates texts within
her photographic work.
Lafontaine, however, in-
scribes her texts – in this
case, 'Pure terror can
awaken in our being at
any moment' – on her
frames, thus transform-
ing these photographs into
memorials.

Thomas Florschuetz
Untitled (Cross) – I, 1991
Four-part cibachrome photograph
Two segments, each: 107 x 72 cm

Thomas Florschuetz regards the
photograph as a form of raw material
that can be adapted only to achieve
the ends he desires through the use

of novel connections and formal
combinations. Here, four lower arms
with fists and fingers, set off against
the background through dramatic
lighting, form a cross.
The image awakens a variety of
associations – from the cross of the
Crucifixion to the limbs of thugs
eager for a fight. In Florschuetz's
photographs, the image of the human
body is hacked up, then re-assembled
in a deeply disturbing manner.

Thomas Struth
**Musée du Louvre IV,
Paris 1989**, 1989
Colour photograph (no.
8 of an edition of 10,
printed in 1993)
184 x 214 cm

Thomas Struth's cam-
era eye makes a work
of art out of the act of
looking at works of art.

The masterpieces of European art are presented in their museum settings in the style of photographic reportage, yet compromised in their immediacy and once again made into observed objects through the gaze of the photographed spectators and then through his, observers of the photograph.

Patrick Raynaud
'Histoire comique des Etats et empires de la lune' –
à Savinien de
Cyrano de Bergerac
(1619-1655)
Château de Presteneck,
1992

Four cibachrome photographs in light boxes
Each segment: 43 x 122 x 122 cm

Raynaud's four-part globe is a photograph too; and, at first sight, it appears that it is a photograph of a map of the earth. Only on closer inspection is it apparent that these strange segments of a planet are not in fact segments of the earth. Rather, they make up the moon, lit as if from within as a four-part transparency, and presented as an image competing with the familiar image of the earth as dismembered by geographers.

Sculpture

Günther Förg

Four Masks, 1994

Bronze, in four parts
Masks: 33-42 cm x 26-35 x 13-17 cm
(including pedestals:
188-194 x 44 x 44 cm)

As long as a work of sculpture is made of bronze and stands on a pedestal, it meets the expectations that we conventionally bring to this category of art. Günther Förg has placed four heads on thin rods and so raised them, as clumps of metal, to hover above their respective pedestals. As we approach these heads, however, we find that our expectations are not exactly fulfilled. These surrogate 'faces' are not those of individuals; they are not recollections of heads that were once alive. Rather, they are formless, doughy entities, suggestive of matter in a state of decomposition.

Christian Boltanski

Réliquaire (Reliquary), 1990

Black-and-white photographs, four hundred biscuit tins, sixteen metal drawers, sixteen lamps Overall dimensions variable:
c 300 x 215 x 94 cm

Christian Boltanski goes about preserving a memory of the human face in quite another way. Large portrait photographs are stuck on to tin boxes that are piled up to form an altar. Each of the photographs is dramatically lit by a small lamp. Boltanski calls his collection of portraits a 'reliquary' as if the dead recorded in the photographs actually lived on in them, just as we may imagine their ashes are preserved, in the containers (or reliquaries) here piled up to form an altar. Though long departed, their mysterious identities, picked out by lamps, still haunt us.

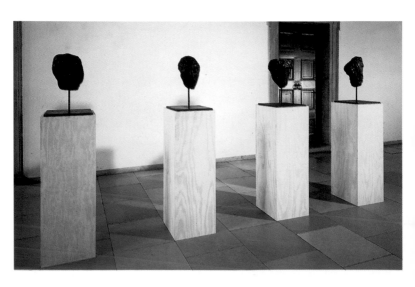

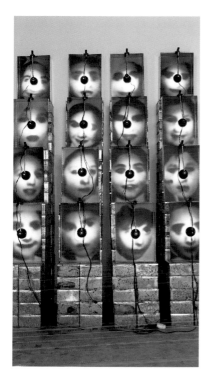

Ulrich Rückriem

Untitled, 1989

Two-part work in bleu de vire granite

Each segment: 200 x 200 x 30 cm
Overall dimensions:
200 x 500 x 30 cm

In comparison with Christian Boltanski's installations (which are invariably freighted with meaning), Ulrich Rückriem's reliefs appear conventional. They are traditional stone reliefs, even though deprived of figurative elements. They are abstract compositions that have taken the material of stone. Cut up into squares, with their proportions determined by the incursions of the stone saw and the bore holes, they introduce the opposition of 'raw' and polished surfaces. It almost appears as if it is only through Rückriem's reduction of form to the qualities of the stone and the way it has been worked that he brings out the full potential of each unit

Imi Knoebel
Betoni, 1990

Sixteen segments of concrete
Overall dimensions:
275 x 275 x 8 cm

bination. We can here detect the traces of a conceptual approach, in which the artist is always thinking one step ahead.

Peter Weibel
Pictorial Geometric Bodies, 1975/93

Three wall objects in cast aluminium
Each segment dia.: 100 cm

Peter Weibel
Trampling Justice Underfoot,
1968/93

Floor sculpture of sixty hardboard panels
Each panel: 204 x 93 cm

Imi Knoebel's sixteen-part work is a wall relief, and thus easily perceived as a planar, unified whole. Knoebel has not, however, made the harmony of proportions and the subtle opposition of the stone surfaces his subject here. It appears almost as if he has grown tired of regular forms, and has preferred to work with irregularly shaped left-overs that have lost every element of balance and yet nonetheless regain something of this through their particular com-

In the vertical part of this installation, Peter Weibel has called back into existence the three basic shapes of Bauhaus geometry – the triangle, the square, and the circle. This gesture is, however, compromised, and our expectations therefore partially disappointed: the triangle is rounded, the square is triangular, and the circle is squarish in its cut. The spectator is likely to be even more perplexed, however, when he has to negotiate the horizontal com-

ponent of this installation: should he understand that he is here being encouraged to recognize justice as the basis on which everything rests, or should he, rather, feel as if summoned to trample justice underfoot?

Media Art

With the emergence of the new electronic technologies, controlled sequences of movement have become possible and have fundamentally altered the art scene. For several years the darkened spaces reserved for video installation have laid claim to their own illusory world, filled with, and defined by, dematerialized yet immensely vivid, moving images. The fixed images of painting and photography have found stiff competition in those flowing, tumbling, and hurtling across piled-up monitor screens and large projection panels.

Stephan von Huene

Dancing on Tables, 1988-93

Inter-, intra-, and re-active sound installation
Four computer-controlled sculptures with movement sensors, fourteen drawings, acoustic infrastructure
Overall dimensions variable
Sculptures each: 200 x 80 x 50 cm
Drawings each: 170 x 115 cm

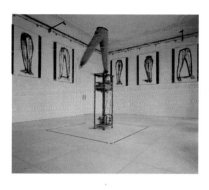

Stephan von Huene's installation shows very convincingly that the traditional distinctions between categories of art have dissolved and that painting and sculpture can be combined within a multi-media 'envir-

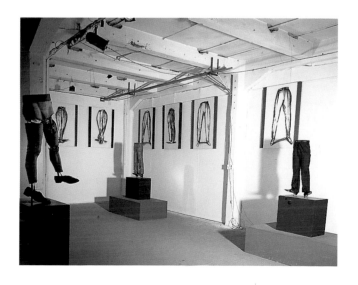

onment' dominated by the computer-controlled movements of dancers. Here, we encounter free-standing sculptures and large, wall-mounted drawings that focus attention on the grotesque image of the legs of dancing men. The introduction of movement, however, alters every attempt at categorizing such a work. The sculpted figures become sound sculptures that do not move, but rather execute controlled sequences of movement in reaction to electronically mediated sound signals.

Nam June Paik
Passage, 1986
Two-channel video sculpture
Thirteen monitors, two laserdiscs, two laserdisc players, wooden television cabinets, cupboard and shelf components, television tubes, light bulbs
348 x 431 x 61 cm

Nam June Paik's *Passage* is a sculpture made up largely of television monitors and related structures. Old television cabinets – objects that are a testament to the history of the media – are piled up to create a triumphal arch between the past and the future. Yet it is soon clear that Paik is here deviously exploiting the 'media nostalgia' he has provoked us to indulge. For these television sets have long been hollowed out and thus have been emptied of their original significance. Now, in place of the familiar black-and-white images, only garish, barely decipherable video sequences race across the screens. This technologically sophisticated inner life does not, however, suit the leisurely pace evoked by the elaborate wooden cabinets:

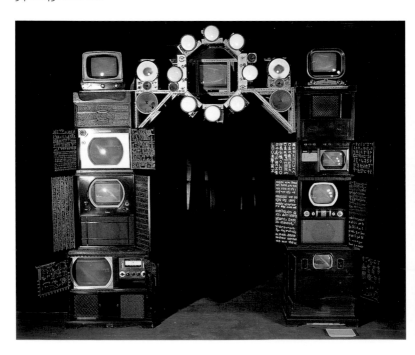

it appears as if about to burst out of these. The spectator is virtually stunned by the flood of images, but his attention is again sparked by the persistence and continuity suggested by

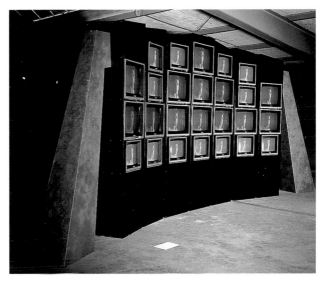

the architectural form of the arch. The complex collage technique of Nam June Paik's work is a concept with which he has been working since the early 1960s. It has long been one of his principal aims to counteract the technological conventions of commercial television.

Marie-Jo Lafontaine
Les Armes d'Acier (Tears of Steel),
1987
Six-channel video and two-channel sound installation
Twenty-seven monitors, six laserdiscs, six laserdisc players, wooden casing
333 × 775 × 270 cm
On the screens of the twenty-seven monitors incorporated into this imposing video installation, Lafontaine shows film of weight-lifters performing in a spirit of pure stoicism. Accompanied by the voice of Maria Callas, these men go through their ath-

letic work-outs without letting their pain show in any way. Behind the façade of absolute self-control, however, the intensity of will increases until it becomes a surrogate form of erotic satisfaction. *Les Armes d'Acier*, the first large video installation to be made by Marie-Jo Lafontaine, is a key work in her oeuvre.

Lafontaine works simultaneously as painter, sculptor, and photographer. The shift from one medium to another does not occur arbitrarily, but in each case it takes into account the potential and the expressive scope of each category of art. Lafontaine's painting is exclusively abstract, minimally reduced to the pure expression of calm planes of colour. Her photography allows her a certain objectivity, that is to say, a partially mimetic relation to reality. Video installation, meanwhile, allows her to create settings in which to tell a story.

Marie-Jo Lafontaine
The Sicilian Gambit, 1986/92
Seven-channel video and four-
channel sound installation
Fourteen monitors, seven video-
tapes, seven videotape players, six
wooden bases, six steel cabinets
Overall dimensions variable
Two steel cabinets, each:
76 x 340 x 73 cm
Four steel cabinets, each:
71 x 77 x 67 cm
Two bases, each: 157 x 300 x 58 cm
Four bases, each: 165 x 71 x 63 cm

Here, three video sequences orches-
trate a single great theme. The
images of a cock fight, a (Sicilian)
funeral, and a chess game (the
gambit, or opening) reveal, in their
striking setting, the fatal interweav-
ing of love and conflict, game-
playing and death.

Fabrizio Plessi
Cariatide, 1990
One-channel video sculpture
One monitor, one videotape player
with digital image memory, bricks,
steel frame
230 x 52 x 52 cm

As in almost all of Fabrizio Plessi's
works, in *Cariatide* he addresses
the question of the difference be-
tween reality and fiction. A pile of
bricks appearing on a monitor
screen serves as the base of a

column and seems just as solid and static as the real bricks that appear above it. Plessi, then, bestows on his monitor image a paradoxical role: here, illusion supports reality, not vice versa. Plessi's *Cariatide* is intended not only to represent the difference between reality and fiction, but also to hint that an image on a monitor screen can, indeed, support the 'weight' of reality.

Fabrizio Plessi
Tempo Liquido (Liquid Time), 1993

One-channel video installation
Twenty-one monitors, one laserdisc, one laserdisc player, mill wheel, steel tank

5 x 4 x 18 m

Tempo Liquido is counted amongst Fabrizio Plessi's key works. This five-metre-high wheel is a steel construction that, on every blade, shows a monitor on which falling water can be seen. With its monitors, the constantly turning wheel submerges into real water which bubbles out of a chute and appears to rush down the mill wheel. Plessi's artistic strategy lies in allowing a stark confrontation between reality and illusion to take place. Just as the water shown on the monitors of the mill wheel is submerged in real water, Plessi juxtaposes appearance with reality in many of his works. The media art of moving images displays a strong affinity with reality, and is, simultaneously, the means by which illusion can be unmasked.

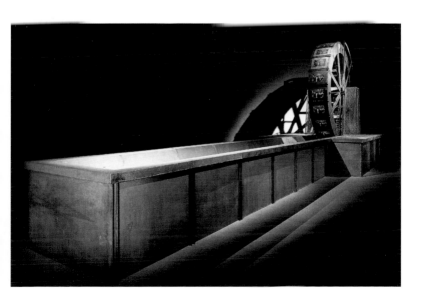

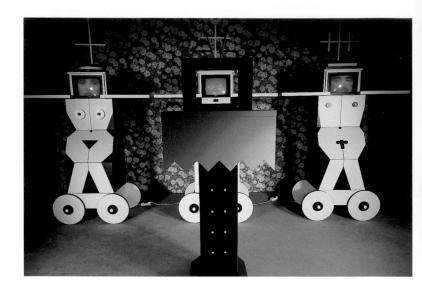

Friederike Pezold
The Last Family, 1990

Three-channel video installation
Three monitors, three videotapes,
three videotape players, four wooden
figures
Overall dimensions variable

The video installations made by the
Viennese artist Friederike Pezold are
especially notable for their sculp-
tural qualities. Their almost motion-
less forms counter today's more
familiar frenzy of film, television,
and computer images following
each other in swift succession.
Through this means, Pezold hopes
to force the spectator to focus with
immense concentration on very
little. In her *Goddess Body Temple* the
almost static image of the protag-
onist is housed in a building remin-
iscent of a temple. The video instal-
lation *The Last Family* incorporates
three monitors, their screens show-
ing, respectively, the heads of a wo-

man, of a dog, and of a man. Be-
cause these video images are so still,
the unsuspecting spectator may be-
lieve that he or she is looking at
three photographs stuck on to the
three screens. Then, however, the
woman's barely perceptible eye
movement, or the slight movement
of her head, or the dog's unexpected
yawning is noticed. Through this
quasi-paralysis, Pezold conveys the
sterile world of a 'family' in which a
dog takes the place of a child.

Bill Viola ▷
Threshold, 1992

Three-channel video and two-
channel sound installation
Nine laserdiscs, three laserdisc
players, three video projectors, two
LED news display strips, permanent
connection to a news agency
Overall dimensions variable
c 360 x 480 x 620 cm

In this work, the American artist Bill Viola uses seemingly immobilized images to present the spectator with an extreme impression of calm. The interior of the installation *Threshold* is surrounded by a swiftly moving LED news display strip. The frantically hastening letters report the latest news as it is issued by a press agency. The spectator passes through the news strip into the space, leaving behind it and finds himself surrounded by the enlarged wall projections of three human heads: two male and one female, resting on pillows. The eyes of all are closed, they are asleep; and the only movements are those associated

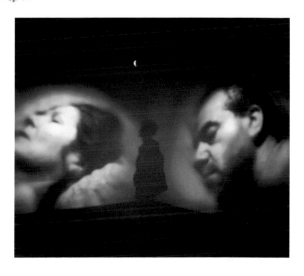

with sleeping and breathing. The calm of the sleepers makes an overpowering impression on the spectator as he enters the darkened interior. Viola evokes the compelling fiction of an inner world effectively sealed off from the outer one.

Bill Viola
The City of Man, 1989

Three-channel video and four-channel sound installation (no. 2 of an edition of 2)
Three laserdisc, three laserdisc players, three projectors, three projection screens
Overall dimensions variable
c 360 x 600 x 800 cm

Total projection area: 214 x 428 cm

Viola's *City of Man* is a compelling testament to the fact that video art draws important inspiration from the tradition of European painting, and in fact might even be said to enter into a dialogue with it. By employing the triptych form, he alludes to the altarpieces of the Medieval period. Like these, this video installation consists of a large central panel and two smaller side 'wings'. The left-hand section represents a contemporary version of Paradise: the dream of the American middle classes. The central section shows the world at its most prosaic: as a place in which people go about their business, establish social connections, and struggle for power. The right-hand section represents Hell, symbolized through the black silhouettes of burning buildings, a realm where destruction and annihilation rule. Each section is accompanied by barely perceptible background sounds. The hum of the traffic on the left and the crackle of flames on the right flank the sound of singing at the centre. From time to time applause or chirping birds can be heard, which are the only elements linking the three otherwise disparate scenes. In comparison with the Medieval model, Viola's 'triptych' offers no clear dramatic structure, no clear narrative. Everything happens at the same time and is seen to repeat itself.

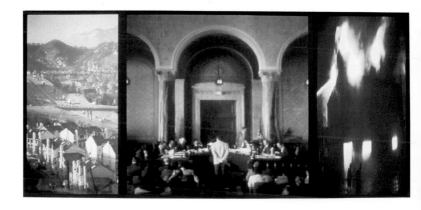

Bruce Nauman

Raw Material – BRRR, 1990
Two-channel video and two-channel
sound installation
Two monitors, one projector, two
videotapes, two videotape players
Overall dimensions variable
c 360 x 500 x 760 cm

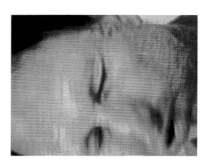

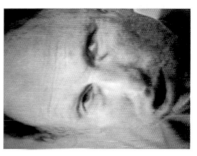

The notion of humanity as de-
formed and distorted has been com-
mon in art since the time of Goya.
In the twentieth century, with the
writings of Kafka and Beckett and
the art of the Expressionists, Da-
daists, and Surrealists, it has be-
come a major theme. The American
artist Bruce Nauman has pursued
this now well-established critique of
the harmonious image of man,
translating it into the new art form
of the video. Through the moving
images used in this new medium,
this critique assumes an unexpected
directness. The almost unbearable
importunity of the childishly stupid
man, who forces a meaningless

'BRRR' between his lips is intensi-
fied through the curious juxtaposi-
tion of two monitors and a large
wall projection. Nauman unmasks
the image of the perfect human
being and uncompromisingly
shows him in all his disfigurement
and risibility.

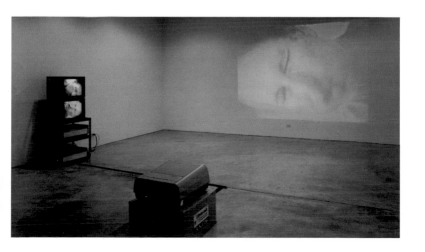

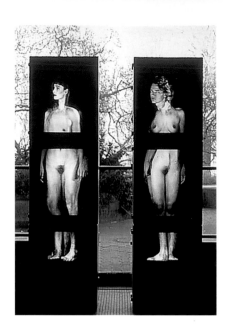

Franziska Megert
Playing with Fire, 1989

Six-channel video and two-channel
sound installation
Six monitors, six videotapes, six
videotape players, two bases
Overall dimensions variable
c 250 x 180 x 100 cm

Franziska Megert
Arachne-Vanitas, 1991

Six-channel video and two-channel
sound installation (no. 1 of an edi-
tion of 3)
Six monitors, six videotapes, six
videotape players, two bases
Overall dimensions variable
c 250 x 180 x 100 cm

Franziska Megert's *Playing with Fire*
and *Arachne-Vanitas* are two parts of
a trilogy. Two human figures are
juxtaposed in such a way as to dem-
onstrate both physical mutability
and psychic contradiction. Each of
these works consists of two stacks of
three monitors, showing video foot-
age that combines to form a sort of
video collage. In the first case, we
see images of a man and a woman
whose 'playing with fire' ends with
their melting into each other: the
tongues of flame allow female forms
to flicker up in the image of the man
and vice versa, so that a seemingly
androgynous creature emerges. In
Arachne-Vanitas we encounter im-
ages of a young woman and an old
woman that progressively flow into
each other to form a single body that
is neither young nor old and that
has effectively lost its material quali-
ty, transcending this as it enters the
psychic and spiritual realm.

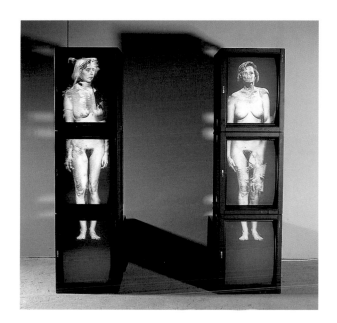

Ulrike Rosenbach
Or-Phelia, 1987

Three-channel video and two-channel sound installation
Three monitors, three laserdiscs,
three laserdisc players,
steel casing, glass plate
c 66 x 65 x 147 cm

Ulrike Rosenbach's video installation, consisting of three monitors set into steel casing, reconciles the antagonistic poles of male and female, of love and culture. The title alludes to the myth of Orpheus and the story of Ophelia (in Shakespeare's *Hamlet*), both of whom symbolize vain striving for what remains inalterably 'other'. Orpheus, through his song, was able to reclaim his beloved Eury-dice from Hades; but, because of his failure to trust in the efficacy of his own powers, he again lost her. Ophelia, meanwhile, drowned herself out of unrequited love. Rosenbach com-

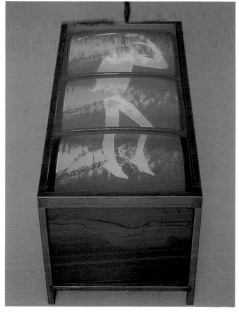

bines Orpheus and Ophelia to create a new 'Or-Phelia' myth, making use of the suggestive image of the river. The images on the three monitor screens nestling in their 'sarcophagus' suggest an enlargement of the microscopic record of blood, pulsating with life. 'Floating' within this, in a sly paraphrase of John Everett Millais's painting of Ophelia, we find the figure of Orpheus-Ophelia, white as a ghost and yet turning as if in a troubled half-sleep.

Ingo Günther
In the Realm of the West-Wind-World, 1991

Two-channel video installation
Two masts with flags, two wind machines, two projectors, two laserdiscs, two laserdisc players
Overall dimensions variable

Height of masts each: c 350–450 cm; flags each: 120 x 190 cm

Two flags, each completely white and each fluttering at the top of a mast, resemble each other and almost touch each other. Video images are projected on to them. First we see the flag of the United States and that of the Soviet Union, with one appearing to turn into the other, and vice versa; then leaders of each of these countries and events from their recent history, with a similar tendency to blend and swap. This repeated pattern establishes the notion of a fundamental exchangeability of two ostensibly opposed systems and sets of ideas. *In the Realm of the West-Wind-World* pursues concepts treated in some of Günther's earlier works, where he had addressed the

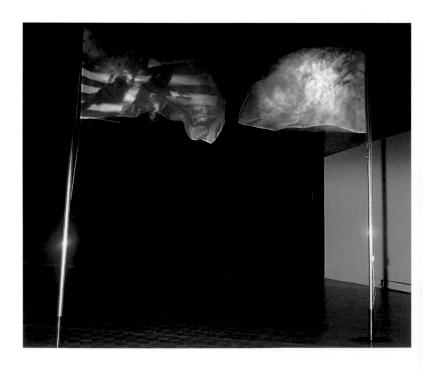

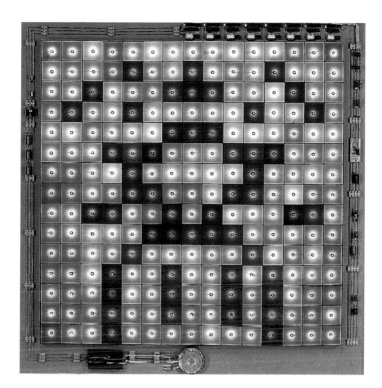

power of the state, systems, and ideologies. The two fluttering flags symbolize the rapprochement between the two superpowers in the era of perestroika. At the same time, the video images themselves refer to the role of the media in this process. The fall of the Iron Curtain could thus also be seen as masking the triumph of the media over declared political programmes.

Walter Giers

Large Sliding Symmetry, 1992

Electronic wall object, controlled by a random generator
120 x 120 x 6 cm

With this lyrical and meditative electronic wall object, the artist, engineer, and jazz musician Walter Giers occupies the borderland between music, the visual arts, and technology. In the objects devised by Giers, one finds a combination of order and austerity, contemplation and playful high spirits. Innumerable points of light create a seemingly endless series of symmetrical patterns in a rhythmic tangle. Batteries, wires, capacitors, resistors, transistors, and bulbs are familiar components that are here arranged and interconnected in a novel way to produce surprising effects.

Walter Giers
Art – Statement – Art, 1993
Installation of 50 loudspeakers with
sound module, controlled by a ran-
dom generator
Overall dimensions variable
c 200 x 170 cm

With his particular feeling for the
grotesque, Walter Giers resolved to
collect fifty old loudspeakers and to
arrange them 'sculpturally' into a
somewhat formless cluster. From all
of these loudspeakers there issues
the continuous sound of the voices
of people Giers has interviewed, and
to whom he has posed the question:
'What is art?' Their answers, re-
corded on tape, are heard as if they
were all speaking at the same time,
and are thus perceived as an impen-
etrable, cacophonous muddle. Giers
thus offers a wittily vivid

embodiment of the cacophony of di-
verse opinions almost inevitably pro-
voked when one poses this question
about art.

Andor Weininger
Design for an Electro-Mechanical
Bauhaus Stage Set, 1926

Wanzke/Steger/Budesheim
Blue-Grey Remains Blue-Grey
Electro-mechanical stage set based
on Andor Weininger's
Abstract Revue, 1926

Realized in 1986
Various elements of set design,
steel pipe, wooden poles, partitions,
cloth strips, turning rolls, turning
cylinders, electronic motors, four
figurines, loudspeaker boxes, flood-
light and spotlights, two control
panels, tape player, computer
c 340 x 650 x 270 cm

The large-scale installation *Blue-Grey Remains Blue-Grey*, realized by Reinhard Wanzke, Jürgen Steger, and Jörn Peter Budesheim, offers a historical perspective on the moving images of the avant-garde of the 1920s, the kinetic constructions made at the Bauhaus, and the mechanical theatre devised by Andor Weininger in 1926. Weininger himself called his work 'Abstract Revue'. This was a so-called electro-mechanical ballet; and in 1986 it was re-created, using modern technology, by a group of artists in Kassel and presented at the following year's 'documenta VIII'. In the ballet developed by Weininger, abstract forms appear on a stage and, through the use of altering light effects and their own continual movement, they produce continuously alternating compositions. In the form of *Blue-Grey Remains Blue-Grey*, Weininger's re-constructed *Abstract Revue* belongs to the collection of the Center for Art and Media. Thus, in the midst of today's moving images, it recalls the moving images of yesterday.

The Media Library

The Media Library (Mediathek) offers the visitor one of the world's most comprehensive collections of contemporary music, videos, and literature on the art of the twentieth century. It is a real mine of information for researchers, but also a place where the non-specialist can come to look and listen – and incidentally learn a great deal. Research is made easy: information on particular artists and works can be called up directly from the databank: videos and CD-ROMs can be swiftly surveyed and selected, then played one after another using a juke box system. The viewing and hearing booths attached to the databank offer the visitor innovative ways of enjoying images and sounds; in addition, specially designed audio-chairs and a seminar room equipped for multi-channel playback invite him or her to embark on extraordinary journeys through the world of sound. Researchers may use the special study areas (located away from those open to the general public), where they can work undisturbed. The Media Library can also be 'visited', and research into its holdings pursued, via the Internet. Items from the collection – be they videos, CDs or books – cannot, however, be lent out to users, but must be consulted on site. The Media Library embraces the Audio Collection (Audiosammlung), the Video Collection (Videosammlung), and the Library (Bibliothek).

An audio-chair in the Media Library

Functioning rather like conventional juke boxes, those to be found in the Media Library will play on demand any material from its archive

The Audio Collection

The Audio Collection specializes in contemporary, in particular electro-acoustic, music. It currently holds a total of over twelve thousand titles of recorded music, supplemented by an extensive collection of scores, specialist literature, documentary photographs and posters. The Audio Collection is divided into twelve sections, although these are extensively interconnected. Of particular significance is the International Digital Electro-Acoustic Music Archive (IDEAMA). This contains a recording of every important piece of electro-acoustic music dating from the beginnings of this genre to the present day, and has been established in collaboration with Stanford University. Previously, early examples of electro-acoustic music were recorded on tape, which had inevitably decayed over time. In order to save such unique documents of contemporary musical creation, these were transferred on to CD. Simultaneously, a basic collection – containing the 'best of' electro-acoustic music between 1929 and 1970 – was recorded. Among the highlights of this collection are, for example, the first electro-acoustic piece ever devised, Walter Ruttmann's *Weekend*, and a number of previously unpublished works by, for example, the 'Groupe des Recherches Musicales', Paris, the 'EMS Studio' Stockholm, the 'Studio di Fonologia', Milan, and the Siemens-Studio, Munich. In addition, the Center administers the

Thomas Gerwin (Director of the Audio Collection) tries out equipment in the electronic music studio bequeathed to the Center for Art and Media by the late Hermann Heiss

Zentralarchiv der Deutschen Gesellschaft für elektroakustische Musik [Central Archive of the German Society for Electro-Acoustic Music], which is committed to recording and collecting every electroacoustic piece produced in Germany.

The section of the Audio Collection called 'Music of the Modern Age' contains a great many important works by major composers such as Arnold Schönberg, Alban Berg, Pierre Boulez, Karlheinz Stockhausen, and John Cage. The Audio Collection also contains extensive information on the most important annual (or otherwise regular) festivals of new music – for example, those held in Darmstadt or Donaueschingen. Other types of music, such as jazz, blues, rock, and pop are not, however, ignored. Rock fans, for example, can discover classics of the genre – the music of the Beatles, Frank Zappa, or Pink Floyd. The Audio Collection also embraces material from areas indirectly related to electro-acoustic music, such as multimedia productions, studies of material, composition sketches, or excerpts from live recordings. In a 'Cabinet of Curiosities' the visitor or researcher can select from a wide range on offer, and in particular can unearth rare or interesting items, for example an electronically spruced up recording of Enrico Caruso – who, for once, can be enjoyed without the intrusion of crackling or hissing sounds. Further sections of the Audio Collection are devoted to experimental radio plays and experimental film music. An item of particular interest is the stu-

dio of the composer Hermann Heiss (1897–1966): this is one of the last electronic music studios to survive. It was acquired by the Center for Art and Media in 1994.

An especially attractive feature of the Audio Collection is the group of sound portraits of particular cities. As the visitor will find, great cities such as Lisbon, Amsterdam, or New York have their own acoustic profile. At the Center for Art and Media, Thomas Gerwin has combined these into a *Sound Atlas* (see p. 27), an interactive sound installation that is to be found in the Media Museum. Here, the visitor can call up individual sound portraits and mix them at will, so as to create new and exciting acoustic city environments. The entire collection of sound portraits is also available on CD and is accesible on the Internet.

The Video Collection

In the space of a few decades video has evolved from a technological experiment for amateurs to a true mass medium. The swift pace of commercialization – notably , the video boom of the 1980s – has tended to distract attention from the artistic aspect of this medium. The purpose of the Video Collection at the Center for Art and Media is to raise awareness of video as an art form in its own right. This is the first collection of its type in Germany with a professional commitment to the permanent presentation of the art history of video. The Video Collection holdings span three decades of production, starting with a volume by Wolf Vostell made in 1963, *Sun in Your Head*. The Video Collection now contains over five hundred in-

David Larcher, Test-Videovoid, *1996*

Woody Vasulka, The Art of Memory

dividual titles with a total running time of one hundred and twenty hours. Every significant tendency within video art is represented. There is an almost complete record of the video work of leading artists such as Nam June Paik, Bill Viola, or Gary Hill; and particular attention has been paid to collecting not only individual works by particular artists, but also groups of works and examples from various periods. The Video Collection continues to grow. Videos winning prizes at the 'Internationaler Videokunstpreis', for example, are added every year.

Another key feature of the Video Collection is its possession of a complete run of the video magazine *Infermental*, published between 1982 and 1991. With a total of eleven volumes, embracing six hundred and

sixty individual works, this was the first international magazine to appear in a video format and it offers a unique document of the video art of the 1980s. Founded by the Hungarian experimental film-maker Gabor Body, *Infermental* was published in a different country each year, altering its focus accordingly. The range of material in the entire series of *Infermental* is therefore enormously wide, embracing flickering black-and-white experimental film from Poland (in which the difficult production conditions are very clear) to the technological perfection and sophistication of Japanese computer animation.

The Video Collection sees one of its most important tasks to lie in the conservation of early video tapes that are now beginning to decay.

These are all now transferred on a digital format, and it is planned eventually to be able to store and make them available on digital video disc (DVD). This medium offers not only superb image quality, but also much greater storage capacity than a CD-ROM.

In order to further encourage public awareness of video as an art form the Center for Art and Media has, since 1992, awarded an annual prize – the 'Internationaler Video-kunstpreis' – in collaboration with the German broadcasting channel, Südwestfunk. Competition for this prize is announced publicly and the total prize money, a sum of DM 65,000, may be shared betweeen a maximum of three prize winners. Of the works submitted each year, fifty are selected and shown on German, Austrian, and Swiss television channels – respectively Südwest-funk, ORF 2, and SF DRS. The prize winners are chosen from this group of fifty and the awards presented at an annual ceremony. One important aim of this collaborative exercise is to remove the barriers still persisting between traditional television programming and experimental work in video.

The Library

The Library, which the Center for Art and Media shares with the Academy of Design, contains a total of approximately twenty thousand volumes and CD-ROMs. Information on its holdings is provided through a library association responsible for the whole of south-west Germany. In addition, the library subscribes to around one hundred and twenty journals, among them some very rare specialist publications. The part of the library collection stored on open shelves is arranged according to subject, and is strongest in those areas that correspond to the perceived role of the Center for Art and Media and the faculties within the Academy. Its coverage is therefore strongest in the art of the twentieth century, above all media art, architecture, design, media theory, film, photography, and electro-acoustic music. Also well represented are theatre, art history, philosophy, and other areas. Each year around two thousand items are added to the collection.

Research facilities at the Library of the Center for Art and Media include speedy access to the various databanks and to the Internet. Separate desk space is reserved for researchers.

The Media Theater

The Media Theater (Medientheater) is the Center for Art and Media's principal setting for multi-media events. It is an open-plan venue for production and presentation, into which the new media can be very flexibly integrated. Classical forms of presentation such as plays, dance and concerts are, of course, possible in the Media Theater, although there is no fixed boundary between spaces functioning as 'stage' and 'auditorium'. The Media Theater also meets the highest technical standards that might be required by those using it as a lecturing space, a cinema, or a studio for live broadcasts on television on the Internet or on radio. For experimental productions of every kind it offers a setting of extreme technical sophistication.

The Media Theater is located in the sixth atrium and is an independent architectural entity. While its total surface area of three hundred and forty square metres is relatively small, its height of fifteen metres contributes to its overall capacity and offers further room for technical facilities. The angle of 3.5 degrees at which the walls curve inwards offer an unusual sense of space.

The layout of the Media Theater can be variably arranged. For film projection or lectures it is possible to employ a conventional raked auditorium facing the front and standard presentational or speaker space. Depending on the exact arrangement, this may offer seating for an audience of up to three hundred.

For other types of presentation the seating can be arranged in many different ways – from unraked to steeply raised, with seats surrounding a central 'arena'. The Media Theater can also be adapted to suit 3-D projection or 'blue box' technology, with the addition of a continuous black-and-blue curtain, a white 'circular horizon' let down from above, and a large projection screen. Amongst the production facilities offered by the Media Theater is a large 'Live Sound Mixing Board'.

In addition to its own resources and production facilities, the Media Theater can draw on those of the Institute for Visual Media, the music studios, and the large, digital sound workshops in the 'blue cube'. By means of connections to the Center's internal cable television network, it is possible to broadcast every Media Theater production to every part of the institution. It is thus also linked with all the computerized services offered by the Center for Art and Media and, through this route, linked with the international 'information superhighway'.

Research and Development Departments

The Center for Art and Media includes two departments fully committed to research and development: the Institute for Visual Media and the Institute for Music and Acoustics. Though largely invisible to the general public, these are in many respects the true heart of the Center. Both institutes offer artists from all over the world an ideal production environment and a forum for discussion, in which the new technologies can be explored and contemporary trends pursued or, perhaps, rejected. Many of the art works now on display in the two museums of the Center for Art and Media were actually made here. Also unique is the fruitful collaboration between artists from different spheres and between these and information technologists, scientists, and students from the affiliated Academy of Design. Among the results of such collaboration have been some striking multi-media works of art with a strong experimental character, for example, the music theatre piece with 'virtual' sets that was devised for the fifth Multimediale festival.

The Institute for Visual Media

The Institute for Visual Media is a forum for creative and critical engagement with the continuously evolving conditions of media culture. It offers guest artists from all over the world the opportunity to create innovative artworks that exploit the latest developments in media technology. For this purpose artists have access to the Institute's resources which include computergraphic systems, digital video equipment, a virtual studio and a multi-media laboratory. A further major emphasis is the in-house research and development of new hard- and software tools appropriate for artistic needs.

Many of the works of art created at the Institute for Visual Media – first shown at the ZKM's biannual Multimediale festival – have subsequently attracted critical acclaim at international exhibitions such as the Lyon Biennale, Mediascape at the Solomon R Guggenheim Museum New York, the Interactive Media Festival in Los Angeles and the Ars Electronica in Linz. Now that the ZKM has its own extensive exhibition spaces, the works produced at the Institute can be presented on site to a broad public for extended periods of time. Artists working at the Institute for Visual Media also often profit from collaboration with research institutions in Karlsruhe such as the University, while co-productions and joint presentations

have been made with media art centres worldwide, for example the NTT InterCommunication Center in Tokyo and Le Fresnoy, Studio national des arts contemporains in Tourcoing in northern France.

The Institute for Visual Media focuses its activities on those media technologies that are of particular significance for contemporary art practice. These can be broadly categorized as follows:

- digital video
- interactivity
- virtual reality
- simulation
- telecommunication
- computer graphics
- multi-media and CD-ROM

Digital Video

While video technology was initially closely associated with television broadcasting, it has now converged with computing technologies to become a digital production medium that gives artists a broad range of new forms of expression. This encompasses video sculpture (e.g. Nam June Paik), interactive video disc installations (e.g. Garry Hill),

David Larcher, I, the Tank, *1997*

interactive multi-media installations (e.g. Bill Seaman), teleconferencing (e.g. Paul Sermon), virtual reality (e.g. Peter Weibel), and new forms of visualization within the medium itself (e.g. David Larcher). A further development at the Institute for Visual Media is the 'virtual studio': a completely blue studio with a computer controlled motion camera that allows synthetically created images to be accurately combined in real time with live action. This virtual studio is linked to the Institute's graphics supercomputer and digital Betacam post-production facilities.

Interactivity

The Institute for Visual Media has fostered and pioneered the evolution of interactivity as an art form. The new computer-driven interac-

Toshio Iwai, Piano – as Images Media, *1995*

tive techniques offer a variety of methods by which the viewer can directly influence the manifestation of such artworks. In Toshio Iwai's *Piano – as Image Media*, for example, both sound and image components can be directly manipulated. Jean-Louis Boissier's *Flora petrinsularis* embodies an audio-visual database that can be non-linearly reconstructed. An important research focus at the Institute is the development of interfaces which link the viewer to the interactive artwork. For the installation *Gravity and Grace* by the Japanese artist Yasuaki Matsumoto, a video-image processing system was developed which recognizes the position and movements of the spectator's body. In Chris Dodge's installation *The Winds that Wash the Seas* air current sensors mounted around the monitor allow the spectator to seemingly blow through superimposed layers of video images.

Virtual Reality

A unique aspect of contemporary virtual reality techniques is their ability to create entirely computer-generated worlds which can be directly connected with the body of the spectator using for instance a head-mounted display or more simply a bicycle (Jeffrey Shaw's *Legible City*). While the traditional activity of art has been to represent reality, the techniques of virtuality now enable the artwork to embody surrogate realities which the viewer can enter and explore. This offers artists new expressive possibilities and spectators new aesthetic experiences.

Because the existing hard- and software products are strongly defined by military, industrial, and commercial agendas, the Institute for Visual Media has sought to develop new virtual reality techniques which are appropriate to the requirements of artists. One example is EVE (*Extended Virtual Environment*) developed in close co-operation with the Research Center Karlsruhe. EVE is an inflatable dome in which a 3D projection system can move the projected image anywhere over the inside surface of the dome. Using a tracking device, the position of the

Jean-Louis Boissier, Flora petrinsularis, *1993*

image is interactively linked to the head movements of one of the spectators and thus follows the direction of his gaze. One of the advantages of EVE is that many people can simultaneously explore a shared virtual dataspace. EVE has been used for example to make possible a virtual journey through the reconstructed Stone Age settlement Çatal Höyük in Turkey (first presented at the third Multimediale). The unique

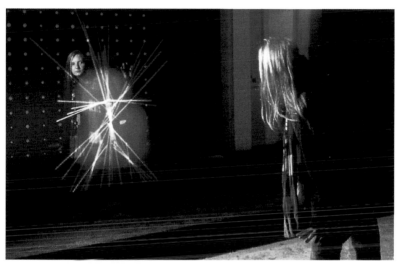

Yasuaki Matsumoto, Gravity and Grace, *1995*

Chris Dodge, The Winds that Wash the Seas, *1995*

EVE (Extended Virtual Environment)

capabilities of this VR environment will be further explored by future guest artists.

The Institue for Visual Media has also developed new software tools which allow artists to integrate animated objects and interactive events within virtual scenes. Bernd Lintermann's 'xfrog' software – developed at the University of Karlsruhe – brings organic forms, artificial life, and emergent behaviour into virtual worlds. Adolf Mathias created software that enables complex animated objects and events to be incorporated into a virtual environment. This development has been used in the interactive music theatre performances staged at the fifth Multimediale.

Simulation

Motion simulation is another dramatic aspect of virtual reality. The Institute of Visual Media has

Simulation platform with The Forest *by Tamás Waliczky, 1993*

Computer animation after designs by Robert Darroll for the threatre piece by Kiyoshi Furukawa, To the Unborn Gods

acquired a six-degree of freedom hydraulic simulation platform – similar to that used for the training of pilots. This is located next to the ZKM's main entrance. With this device artists are able to synchronize actual bodily movement with the movement of images in virtual space (first demonstrated in *The Forest* at the third Multimediale). In the future new artworks will be created especially on an annual basis for this unusual apparatus. For this purpose motion control and editing software have been developed by the Institute for Process Computing Technology and Robotics at the University of Karlsruhe.

Telecommunication

The technologies of telecommunications make possible the creation of virtual environments which can be shared and interacted with by people located far apart from each other. One example is Agnes Hegedüs's *The Fruit Machine* which linked Karlsruhe with Tokyo at the third Multimediale. Telepresence enables the participant to project a representation of himself into another place where they can meet other telepresent persons or 'agents' (as, for example, in Paul Sermon's *Telematic Vision*) Broadband cable and fibre optic networks within the ZKM let artists explore the diverse forms of interactive worldwide communication. Some artists have integrated high resolution images into their televirtual models and extended these capabilities into the Internet – for example Stacey Speigel's virtual telecommunication landscape *Crossings*. It is already apparent that the development of telecom-

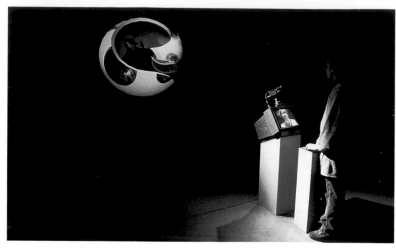

Agnes Hegedüs, The Fruit Machine, *1993*

munication technologies can create social electronic spaces that offer remarkable possibilities for new forms of propagation and dissemination of creative activity. For this reason the Institute for Visual Media is participating in I³ (Intelligent Information Interfaces), a significant, long-term, ESPRIT project of the European Commission in which artists will explore the potential of multi-user, shared, televirtual spaces and events over the next three years.

Computer Graphics

Computer graphics and computer animation are important research

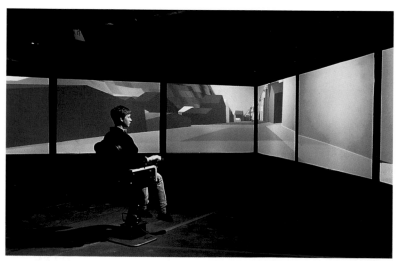

Stacey Spiegel and Rodney Hoinkes, Crossings, *1995*

areas within the Institute for Visual Media. Pioneers of computer animation, such as Tamás Waliczky and Larry Cuba, have created major new works at the Institute. Simulation techniques are especially effective in the computer animation of architectural and archaeological subjects. One example is *Weinbrenner's Dream* (1991-92). This architectural simulation visualizes an unrealized urban plan based on drawings made by Friedrich Weinbrenner in 1797 which proposed a new city centre for Karlsruhe. In 1992 the Institute for Visual Media began the virtual reconstruction of the world's oldest urban settlement – Çatal Höyük in Turkey. James Mellart initiated archaeological excavations there in the 1960s, and his notes along with the drawings made by an artist accompanying him, served as the basis for this 3D simulation. The resulting computer animation is now incorporated into a multi-media database created in collaboration with the Art and Design Academy Kalrsruhe, the European Film Institute and the University of Cambridge. The Institute for Visual Media also made animated sequences for the *Weiherbach Project* (1993-96), on which it collaborated with the Institute for Hydrology and Water Resources of the University of Karlsruhe. The aim of this multi-disciplinary project is a computer simulation of the effects on areas of farmed land of the absorption of pollutants and the resulting strain on water resources.

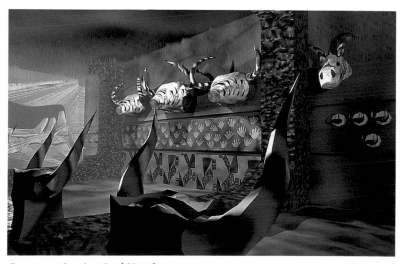

Computer animation, Çatal Höyük

Working in close collaboration with the Media Museum, the Institute for Visual Media established a Multi-Media Laboratory in 1994. This Lab is fully equipped for the production of multi-media projects so that it can support artists who are working in this field – for example Bill Seaman with his *Passage Sets* (1995). In the Multi-Media Laboratory artistic CD-ROMs are being created and, in the future, this will extend to DVD productions. The following CD-ROM publications have already been produced here:

artintact

artintact is an interactive CD-ROM Magazine published yearly and produced in co-operation with the Stuttgart publisher Cantz Verlag. The first edition of this combination of book and CD-ROM was presented at the Frankfurt Book Fair of 1994. The artists Jean-Louis Boissier, Eric Lanz, and Bill Seaman, who were given stipends to work at the Institute for Visual Media in 1993-94, each adapted previous installations for this CD-ROM. The second issue of *artintact,* which appeared in May 1995, contained versions of interactive installations by the artists-in-residence Luc Courchesne, Miroslaw Rogala, and Tamás Waliczky. In 1996 the artists Ken Feingold, Perry Hoberman, and George Legrady were invited to contribute to the third issue. All three had been involved for many years in the field of interactive computer-aided media art and they developed new works expressly for this CD-ROM. The fourth issue, which appeared in autumn 1997, is devoted to younger European artists who have worked with various

Bill Seaman, The Exquisite Mechanism of Shivers *(CD-ROM version), 1994*

Ken Feingold, JCJ Junkman, *1996*

audio-visual media but have so far hardly used the computer as an artistic tool: Dieter Kiessling, Marina Gržinić, in collaboration with Aina Smid, and Anja Wiese. Each issue of *urtintact* is accompanied by a text volume which contains essays on the artists and their work, detailed biographies and lists of works, as well as introductory texts by media theorists such as Dieter Daniels, Christoph Blase, Peter Weibel, and John G. Hanhardt.

The Digital Dance Academy – 'Improvisation Technologies'

A new direction was taken by the Institute for Visual Media in its collaboration with the Frankfurt Ballet and the choreographer William Forsythe. The result has been the development of the interactive computer installation *Improvisation Technologies*. This combines video documentation of the dance piece *Self Meant to Govern* (first presented by the Frankfurt Ballet in July 1994) with video 'chapters' concerning Forsythe's dance theory. In one hundred short sequences, Forsythe himself performs and explains the most important principles of his theory. These sequences were recorded on video, digitalized, and graphically processed. The edited version of the ballet production can be viewed from various angles and is supplemented by video recordings made during rehearsals. Both dancers and dance enthusiasts now have access to an archive that offers the possibility of concentrated individual study and a new approach to the world of one of the most important choreographers at work today.

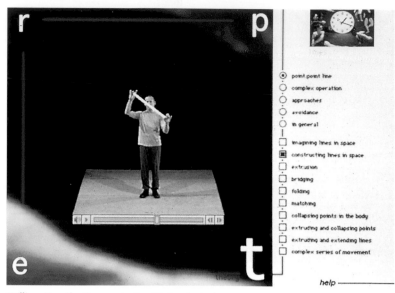

William Forsythe, 'Improvisation Technologies', 1995

One Hundred Masterpieces

In 1996, in collaboration with the Vitra Design Museum at Weil am Rhein and the Art and Design Academy Karlsruhe (HfG), the Media Museum produced a CD-ROM entitled *One Hundred Masterpieces*. This invites the user to take a virtual tour of the Vitra Design Museum. The 'visitor' can explore the various sections at his or her own pace, examine particular exhibits more closely, browse in the museum shop, and listen to the comments of other 'visitors'. The 'hundred masterpieces' – chairs from two centuries that have made design history – can be selected individually and examined in great detail. Precise information on the chairs and their designers is supplied in the form of texts, images, original documents, video footage, and short animated sequences. The exhibits can also be combined into groups in accordance with various criteria, for example, their date. The main menu appears on the screen in the form of a small folding chair, and one can use this to steer one's own path through the various possibilities on offer. Here, then, CD-ROM presentation combines the advantages of visiting a real museum with those of consulting a reference book.

Guest Artists and Projects

- Heiner Blum – *Optical Illusion*
- Jean-Louis Boissier – *Flora petrinsularis*
- Peter Callas – *Seringue*
- Luc Courchesne – *Hall of Shadows*

- Larry Cuba
- Chris Dodge –
 The Winds that Wash the Seas
- Franz Fietzek –
 Chalkboard, Of Useful Things
- Agnes Hegedüs – *Handsight,
 The Fruit Machine*
- Kirsten Johannsen –
 The Panoptic Village, Skins
- Eric Lanz – *Les mains,
 les gestes 2, Manuscript*
- Yasuaki Matsumoto –
 Gravity and Grace
- Simon Perry – *Fugitive*
- Mirosław Rogala – *Lovers' Leap*
- Bill Seaman – *Passage Sets*
- Paul Sermon – *Telematic Vision*
- Maja Spasova – *Sibyl*
- Stacey Spiegel – *Crossings*
- Bill Viola – *The Tree of
 Knowledge*
- Tamás Waliczky – *The Garden,
 The Forest, The Way*

The Institute for Music and Acoustics

Loudspeakers and computers have brought a new dimension to the world of traditional, instrumental-acoustic sounds. Nowadays, by means of combining the loudspeaker with digital technologies, it is possible to produce sounds that do not occur in nature but that the human ear can certainly register. In order to make such new sounds, it is necessary to explore the ways in which the ear, as a sense organ, be-

haves during the experience of listening to music. When new instruments are devised, new playing methods must also be developed. Music, acoustics, and technology are very closely interrelated in terms of the creative process. Yet, the new technologies that are enlarging our musical and acoustic experience can only be effectively employed if musicians and researchers work together and, in the process, learn from each other.

The Institute for Music and Acoustics (Institut für Musik und Akustik) combines artistic production with exciting public presentations and a commitment to research and development. Since its foundation, it has seen artists and scientists collaborating on numerous commissioned pieces as well as works made on their own initiative, which have then been presented to the public – be it at festivals or in concerts, in the series 'Center for Art and Media at the Factory', on the radio, or on CD. The work produced at the Institute for Music and Acoustics includes live electronic pieces for the concert hall, music theatre productions, loudspeaker installations, film music, and radio plays. So far, over eighty guest artists have made use of the facilities offered by the Institute. In addition to these, there are numerous researchers, scientists, students, and trainees, who have come to regard the Institute as an ideal place for intensive musical re-

Performance by BMB con, in Folklore from the Suburbs *at the third Multimediale, 1993*

search and creativity and the public presentation of its results. Through the range of projects it embraces, the compositions it has commissioned, the workshops it offers, and its extensive lecture programme, the Institute for Music and Acoustics has already earned a strong international reputation.

Inter-Media Productions

Over the last few years a series of important inter-media productions have been achieved at the Institute for Music and Acoustics – works, that is to say, in which moving images, music, and computer technology are combined. The Japanese composer Kiyoshi Furukawa programmed and composed various pieces at the Center for Art and Media, in which instrumental music, computer music, and computer graphics are related interactively to each other. *Swim Swan* for clarinet and *The Gift of Lapis Lazuli* for soprano are complex works, in each of which a soloist cues and controls electronic sounds and graphic images. In a certain sense, these were a form of preparation for the music theatre project, *To the Unborn Gods*, a work commissioned by the Center for Art and Media to mark the formal opening of its 'new' building. For this piece the composer Kiyoshi Furukawa and the artist Robert Darroll devised an audio-visual interactive environment for a stage performance. Support for their work was provided by programming and signal processing experts from the two

Sonderborg, Christmann, and Lovens, in actu, *combining music and painting*

institutes at the Center for Art and Media.

The Australian composer Elena Kats-Chernin and the film-maker Kirsten Winter collaborated on *Clocks*, a work commissioned by the Center for the Ensemble Modern. Winter's contribution was a film, in which she achieves a new balance between sounds and moving images. In 1996–97 Kats-Chernin and Winter again worked together on *Smash*. As a rule, ambitious productions such as these demand collabor-

Darroll, Furukawa, computer graphic from To the Unborn Gods

ation with other institutions and various sponsors; and the Institute for Music and Acoustics can, indeed, point to numerous collaborative arrangements. The most important of these remains, however, the close co-operation with the Institute for Visual Media within the Center for Art and Media.

Live Electronic Music/Interactivity

As digital microchips are now fast enough to process music in real time, the computer can itself be employed as a 'live' instrument. At the Institute for Music and Acoustics particular attention is paid to exploring those possibilities not offered by commercial machines. The Ircam Signal Processing Workstation (ISPW) is of particular importance here. This live electronic environment was developed at the Institut de Recherche et Coordination Accoustique/Musique (Ircam) in Paris. The Institute for Music and Acoustics is one of only a few studios to make available to composers and musicians several ISPWs as supported production tools and to programme them for particular projects. The aim here is to employ these sound technologies as variously in an interactive context as would be the case with traditional instruments.

The Ecuadorian Mesias Maiguashca, for example, used the ISPW to produce his cycle of 1993, *Reading Castañeda.* The mere list of required instruments testifies to the complexity of such compositions: flute, cello, voice, string quartet, metal objects,

Mesias Maiguashca, Reading Castañeda, *Bassam-Abdul-Salam performing on metal objects at the third Multimediale, 1993*

NeXT computer, radio baton, live electronic music, and tape recordings. (The radio baton is an interactive instrument that is played like a conventional piece of percussion and that can control live electronic music.) *Reading Castañeda* was first presented at festivals in Bourges, Sofia, Quito, and Luxembourg.

As well as working on his own compositions, the English tuba player and composer Melvyn Poore has adapted the original version of Karlheinz Stockhausen's *Solo,* which used analogue tapes, for the ISPW, so that this composition can now be performed using digital technology. In collaboration with the Freiburg composer Günter Steinke, Poore has also created 'meta-instruments' that allow the two musicians to play as a duo on the tuba and live-electronics. Such 'performances' too have been presented in many cities, including Vienna, Berlin, Liverpool, Freiburg, Mannheim, and Ghent.

Sound Syntheses and Algorhythmic Composition

The computer has now served as a musical tool in synthesizing sounds and in the process of composition for around forty years. The digital sampler, the synthesizer, and sequence programmes, nowadays an integral part of every commercial and private studio, are unthinkable without the computer applications in experimental music. The products of the musical instrument industry encourage the use of predetermined sounds and processes. The Institute for Music and Acoustics, on the other hand, favours open systems that facilitate innovation and differentiation at all levels.

A member of the Institute for Art and Media, the American composer and computer programmer Heinrich Taube, developed the composition software 'Common Music/ Stella' that has now been used successfully all over the world – above all in universities and in electronic music studios committed to the research and the training of composers. The composer Ludger Brümmer used 'Common Music' to devise his composition *Ambre, Liluc.* It allowed him to achieve a combination of new sound colours and spatial sound movements such as would not have been possible with any other method. Using his own programming language, Taube himself created compositions for string orchestra, electronic cello, and computerized sounds, as also for the mechanical dance hall organ 'The Busy Drone'. The Austrian scientist Gerhard Eckel and the Spanish composer Ramón González-Arroyo collaborated at the Institute for Music and Acoustics to develop integrated composing software, which permits the combination of algorhythmic composition and the signal processing of sounds.

The Loudspeaker as Instrument

The electronic media can only be heard through loudspeakers; loudspeakers are themselves their 'instruments'. The Institute for Music and Acoustics connects the long tradition of multi-channel loudspeaker projections with surround-sound.

For example, the digital control systems for multi-channel sound projection as required by the Karlsruhe composer Sabine Schäfer for her installation *Topophonie* was developed in the institute.

In the control rooms and studios of the new 'blue cube' building, various configurations of loudspeakers are installed in paralell. Distributed

Harry de Wit, Songs for the Pigeons, *for flying grand piano, fog horns, and accompaniment, at the third Multimediale, 1993*

The Ensemble Modern in concert at the fourth Multimediale, 1995

throughout the Media Theater there are only loudspeaker connection points. In addition, there is a loudspeaker studio, in which music can be directly switched back and forth between several loudspeaker systems of various design. Here, musicians, interested members of the public, and music lovers can train their ears for the loudspeaker as an instrument – an important preparation for work with synthetic sounds and for the appreciation of instrumental recordings.

Recording and Production Studios

Centres for computerized music require complete studio facilities in order to be able to process and present their work professionally. The Institute for Music and Acoustics possesses an outstandingly well equipped suite of studios. This allows the highly developed digital audio technologies – now standard issue in the media industry – to be incorporated within the artistic production process from the start, then tested to their limits.

Specialist On-Site Guidance and Publications

In the world of digital signal processing, close co-operation between artists and scientists is essential. In the case of live electronic music, co-operation between engineers and artists is a pre-condition for innovative work. Expertise in acoustics, signal processing, and information technology is required for highly complex synthesis programmes; and guest artists at the Institute for Music and Acoustics can depend upon the assistance of resident experts. Here, intensive basic research is continuously carried out, as in the case of the interactive exhibit *Architecture and Music Laboratory* (see p. 26), developed for the Media Museum.

The Institute for Music and Acoustics collaborates with comparable institutions abroad, such as Ircam at the Centre Pompidou, Paris, the Computer Music Center at Stanford University, the Association pour la Création et la Recherche sur les Outils d'Expression (ACROE), Grenoble, or the Centre National de la Recherche Scientifique Laboratoire de Mécanique et d'Acoustique (CNRS–LMA), Marseilles.

As part of the audio CD series 'Edition ZKM', compositions produced at the Institute for Music and Acoustics are published on the 'Wergo' label. The series of specialist publications in the 'Edition ZKM' series is to be brought out by the renowned music publisher Schott-Verlag. The first volume contains an introduction to acoustics by Donald E. Hall, written especially with musicians in mind.

Collaboration, Festivals, Prizes

The Center for Art and Media collaborates with numerous institutions both in Germany and abroad. In terms of both physical proximity and shared staff, it is especially closely connected with the University and the Atomic Research Center in Karlsruhe, and above all with the city's Academy of Design. Among contacts with institutions abroad, those with Stanford University, the Solomon R. Guggenheim Museum, New York, Ircam at the Centre Pompidou in Paris, and the InterCommunication Center in Tokyo are of particular significance.

Since 1989 the Center for Art and Music has organized a biannual festival, the Multimediale, which presents new work from across the entire range of media art.

In collaboration with the German broadcasting channel Südwestfunk Baden-Baden and the Austrian Österreichischer Rundfunk, the Karlsruhe Center for Art and Media annually awards an international video art prize. Every other year, the Siemens Medien-Kunstpreis is awarded by the Center for Art and Media and the Siemens Kulturprogramm.

General Information

ZKM | Zentrum für Kunst
und Medientechnologie
Lorenzstrasse 19
D-76135 Karlsruhe
Tel: + 49 721 8100-0
Fax: + 49 721 8100 1139

Opening Hours
Museums:
Wednesday to Saturday
12 noon to 8 pm
Sunday 10 am to 6 pm
Monday and Tuesday closed

Media Library (Mediathek):
Tuesday to Saturday
12 noon to 8 pm
Sunday 12 noon to 6 pm
Monday closed

Admission fees:
Museums:
Full-rate DM 10
Concessions DM 5
Combined entry to ZKM and City
Gallery DM 12
Annual family ticket DM 100
Media Library:
A fee of DM 2 is charged for use of
the Media Library only

Further information on the Center
for Art and Media is available at its
Internet website:
http://www.zkm.de

or by e-mail:
info@zkm.de

The 'Gesellschaft zur Förderung der Kunst- und Medientechnologie' (Society for the Promotion of Art and Media) is an association of both individuals and institutions who are interested in supporting the work of the Center for Art and Media, Karlsruhe and that of the Academy of Design, be it through advice or through practical assistance. Their support may, for example, be of benefit to individual projects, to the biannual Multimediale festivals, to individual artists working with the new media, or to especially gifted students.

The Society is recognized as a charitable foundation. Annual contributions start at DM 75 for individuals and DM 750 for institutions.

Further information on the tax-deductability of annual contributions and further donations, as also on other advantages of membership of the Society, may be obtained from the following address:

Gesellschaft zur Förderung
der Kunst- und Medien-
technologie e.V.
Lorenzstrasse 19
D-76135 Karlsruhe

Tel + 49 721 8100 1260
(Christine Stavenhagen)
Fax + 49 721 8100 1139

Index

Photo Credits

Altenkirch, Dirk: p. 11
Atelier Sean Scully, New York: p. 54
Atelier Thomas Struth, Düsseldorf: p. 67 top
Fichel, Rainer, Hamburg: p. 71 top
Florschuetz, Thomas: p. 66 bottom
Galerie Wolfgang Gmyrek, Düsseldorf: p. 59 bottom
Gerwin, Hanno: p. 88
Goldschmidt, Thomas, Karlsruhe: pp. 60, 71 bottom, 72, 73, 74 bottom, 76, 81 top, 84
© Greve, C.: pp. 46, 47
© Günther, Ingo, New York: p. 82
Gursky, Andreas, Düsseldorf: p. 65 top
Harms, Steffen, Karlsruhe: pp. 52/53, 61 top
Hauser, Markus, Hamburg: pp. 77 (2), 97, 99 bottom, 102 bottom
Hegedüs, Agnes: p. 102 top
Huber, Horst: p. 83
Janzer, Wolfram, Stuttgart: p. 67 bottom
Joray, Claude, Biel: p. 58
Kirsch, Guido: p. 113
Klubbers, Marius, Breda: p. 64
Kranl, Walter, Frankfurt/M: p. 69 bottom
Krieg, Irene, Bergheim: p. 61 bottom
Kroll, Bernhard: pp. 6/7
Legay, Christian: p. 34
Littkemann, Jochen, Berlin; courtesy Galerie Michael Werner, Cologne and New York: p. 55

Luxenburger, Martin, Ensdorf: p. 85 (2)
medias artes, Frankfurt/M: p. 66 top
Megert, Franziska, Düsseldorf: p. 80
Mulder, Monique et al.: p. 103
Mundt, Helge, Hamburg: p. 75
den Oudsten, Frank: pp. 16/17
© Douglas M. Parker Studio, Los Angeles: p. 79 (3)
Paul, Katrin: pp. 89, 90
Perov, Kira, Long Beach, California: p. 78
Satzinger-Viel, Klaus, Augsburg: p. 68
Schachinger, Franz, Vienna: p. 57 bottom
Scharff, Christoph, Vienna: p. 70 top
Schaub, Bernhard, Cologne: p. 57 top, 65 bottom, 81 bottom
Schmitt, Bernhard, Karlsruhe: pp. 62, 63, 69 top
Schneider, Axel, Frankfurt/M: p. 70 bottom
Schnepf, Lothar, Köln; courtesy Galerie Michael Werner, Cologne and New York: pp. 56, 59 top
Seitz-Grey, Ursula: p. 74 top
Shaw, Jeffrey and Lebanon Paul: p. 100 bottom
Shaw, Jeffrey: p. 100 top
Thümmel, Konstanze: p. 27
Towata, Masayuki: p. 99 top
de Wit, Harry: p. 112
© ZKM: p. 26
ZKM, Video collection: pp. 91, 92
ZKM: pp. 96, 98, 101, 104, 105, 106, 108, 109 (2), 110

Other ZKM publications from Prestel

Contemporary Art

The Collection of the ZKM Center for Art and Media Karlsruhe

By Heinrich Klotz
336 pages with
390 full-color and
37 b/w illustrations
9 ½ x 11 ¾ in. / 24 x 30 cm.
ISBN 3-7913-1869-1. Cloth.
US$65 Can.$95 £39.95 DM 98

Traditional art forms have been continually adapted and supplemented under the influence of the new media. The Museum for Contemporary Art has built up a unique collection of media art. The selected works discussed in this volume, representing milestones in the field of contemporary art, are compared and contrasted with traditional art forms, thus setting the scene for further discussions on the orientation of future artistic genres.

Media–Art–History

Media Museum ZKM Center for Art and Media Karlsruhe

By Hans-Peter Schwarz
192 pages with 72 full-page color picture collages and 160 b/w illustrations, together with a CD-ROM
9 ½ x 11 ¾ in. / 24 x 30 cm.
ISBN 3-7913-1878-0. Cloth.
US$65 Can.$95 £39.95 DM 98

Spurred on by the electronic impulses of our modern age, the fantastic creative possibilities provided by media art have continuously been further developed. Appropriately, media art has emerged as the creative form of expression of the networked computer society. Supplemented by a CD-ROM, this volume documents the fascinating evolution of this new art form, illustrating the most spectacular works of the international avant-garde, and placing them in an art-historical context.